SHIRE GREEN, WINCOBANK & BEYOND

My brother Keith Woodriff at work.

I would like to dedicate this book to the memory of my younger brother Keith who, up to his untimely death in August 2003, used to be quietly fascinated by our family history and the local history of our area.

This volume is also dedicated to all those kind friends, relatives and neighbours, past and present, in church, school and the wider community, whose reminiscences would fill a library and to whom I will always be immensely grateful.

BRITAIN IN OLD PHOTOGRAPHS

SHIRE GREEN, WINCOBANK & BEYOND

BRYAN WOODRIFF

First Published by Sutton Publishing in 2006

Reprinted 2017 by
The History Press
The Mill, Brimscombe Port
Stroud, Gloucestershire, GL5 2QG

Title page photograph: A Scholar's Reward Card of 1905 depicting the Two-Cylinder Simple locomotive of the Great Central Railway no. 1091, manufactured by Robert Stephenson & Co.

British Library Cataloguing in Publication Data

A catalogue record for this book is available from the British Library.

ISBN 978-0-7509-4414-4

Typeset in 10.5/13.5 Photina.
Typesetting and origination by
Sutton Publishing Limited.
Printed and bound in Great Britain by TJ
International Ltd, Padstow, Cornwall

CONTENTS

ACKNOWLEDGEMENTS

So many people have contributed to this book in so many ways that it is almost impossible to acknowledge each one individually. I have relied heavily on the work done by the Revd William Leary who has become the principal source of church reference after the theft of the Church safe and the loss of so many original documents. I must also pay particular tribute to Velma Furniss, who has been of tremendous assistance with my research through the years. I acknowledge with gratitude the help I have had from Malcolm and Doreen Ayton; Ian and Glynn Bilson and their families; Emmie Bowman née Ellis; Betty Brawn; Ron and Eva Brookes; Joyce Brown née Manifold; Ruth Brown; Roma Brunt; Brian Bullock; Avis Cadman; Brenda Chatterton; Lucy Coplestone; Michelle Dawson; John Dunstan; Jack Hague; Mick Hague; Brian and June Hall; Miss Mildred Hemmingfield; Margaret Hakes; Cllr Jonathan Jones; Pat Jones; Ann and Peter Lockwood; Daphne Marshall; Wendy Mason; Donald Naylor; Barbara Negus; Jack Nugent; the Revd Carol Parker; Kath Rhodes; William Saul; Pat Smith; Gordon Stone; Mike and Pauline Thoday; John Waldron; Dorothy Walton; Ken Whittaker at Firth Park (United) Methodist Church; and Colin Wilson. Thanks are also due to Doug Hindmarch, Sylvia Pybus, Mike Spick and the staff of the Sheffield Local History Library; Peter Nockles at John Rylands University Library, Manchester; Matthew Cates at Click2Print in Hampton Hill; Peter Collins at Aquatint in Hampton; Simon Fletcher, Michelle Tilling and Anne Bennett at Sutton's for unfailing assistance; and finally Dr Vincent Mayr for his assiduous checking of the draft typescript.

I have been grateful to very many kind people who have generously sent me reminiscences and photographs which I have been pleased to see and sometimes to use, and to the others, who have kindly pointed out the odd mistake in previous books; in particular in Book 2 on page 10, the verses of the poem should read alternately: *1, 10, 2, 11, 3, 12,* etc. Although, as usual, I have tried to be as accurate as possible with the information I have used, I am ultimately responsible for any errors that might occur despite the great help given me by Maureen and members of our family.

FOREWORD

BY CLLR JONATHAN JONES
CHAIRMAN OF ECCLESFIELD PARISH COUNCIL, 2005–6

Having read the introductory chapters to this book, I am keen to read the full publication. It gives a fascinating insight into the way of life of many years ago in this important part of north Sheffield and I fully expect that it will generate many fond memories.

It is fair to say that whenever Shire Green is mentioned nowadays many people just think of it as the home of *The Full Monty*. Reading this book will lead, I am sure, to many other attributes coming to mind when talking in the future about the area around Shire Green. In particular, we are reminded of the creation of Methodism and the impact that it has had on this historic area.

As a resident of Burncross for many years, a member of the Methodist Church in Chapeltown – an area just a few miles to the north of Shire Green – and a Councillor on the Ecclesfield Parish Council, I have been honoured to pen the preface to this book and have pleasure in recommending it.

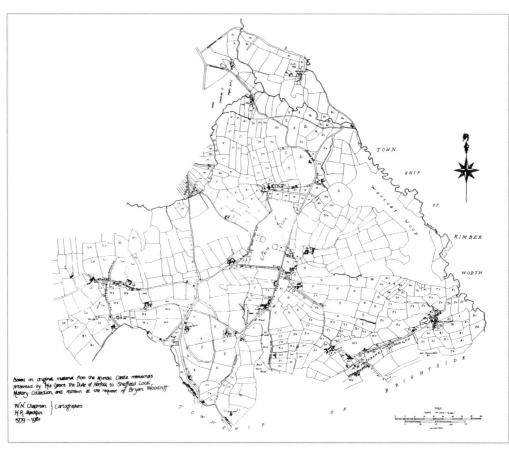

The enclosure maps of south Ecclesfield and north Sheffield from about 1789, combined to show the old Brightside Road running from beyond (Southey) Green in the west to Wincobank Common in the east and crossing the Sheffield Lane and the old Wentworth Road which ran due east from Longley Green in the west, past Crowder House and Brush House towards Bellhouses before turning northwards to cross the Brightside Lane at Shire Green Common.

INTRODUCTION

Maybe it all began many years ago when I was travelling up to Sheffield on the evening 'Master Cutler' train from London. Over the excellent dinner my travelling companion asked, 'Well, where exactly is Shire Green?' It wasn't too difficult to give a reasonably good answer, although he was not familiar with the area. I felt then that we in Shire Green had something to be proud of because all through my younger days I had been able to experience for myself a great deal of the old way of life led by my older relatives and their friends. So I described briefly its location and its timeless quality and put it into its historical setting.

In the mid-1950s, Shire Green still retained many of its historic features which in my innocence I thought would last for ever. Little did I realise how quickly everything was about to change. I failed for almost another decade, despite regular promptings from Mildred Hemmingfield, to take photographs of the many farmhouses, small industries, leisure facilities and local occupations which still existed, albeit on the edge of extinction. Mildred herself had been similarly encouraged by the gift of a camera from her aunt Lizzie Knight in the late 1920s to record the changes then taking place in and around Shire Green.

Several years later a former classmate from Hatfield House Lane Junior Mixed and Infant School, Valerie Lawson, got in touch with me. It was a pleasure to meet her again and I was delighted to discover she was still connected with the old school, then called Hatfield Primary School, and working in the school office. A few days later I invited myself round to the school for nostalgia's sake and to look at the recently found wooden plaque that commemorated its opening. I was delighted when the Headmaster, Ian Vernon, invited me to say a few words about Shire Green to about thirty boys and girls, not in a classroom but in the shelter of the corridor just beyond the Head's room, outside what used to be Miss Binney's classroom for Standard Vb, as I recall. This was a classroom full of happy memories from my last year at school in 1944. Miss Constance Copley, the Headmistress, had given permission to a group of us, including Terry Egglestone, Pat Jones, Pat Clarke and Donald Naylor, to organise a leaving concert at the end of term. For a week or so we were left to our own devices, with a clear run of the stock-room.

The concert was a great success. Because of his conjuring tricks I think Terry was the star performer, but I shall remember him best for his beautiful rendition of the old folk song, 'Soldier, soldier, won't you marry me, with your musket, fife and drum?' in which he dressed up, acted and sang both roles.

The preliminary question I put to the children in my audience was, 'Is Shire Green famous for anything in the past or in the present?' I was not too surprised when they all chorused, 'No.' So my twenty-minute talk lasted about an hour and I was pleased to see

Details from earlier cartographic drawings showing some of the area's buildings, farms and workshops at the turn of the nineteenth century.

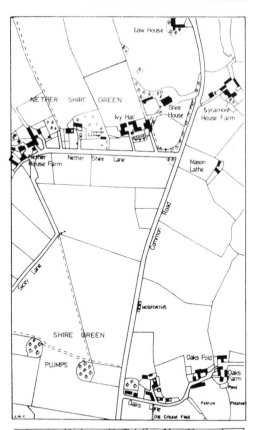

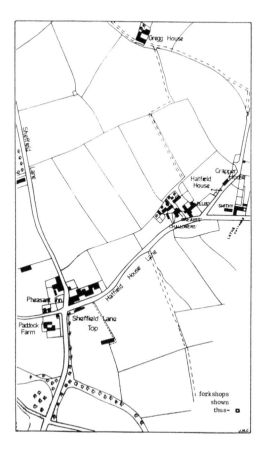

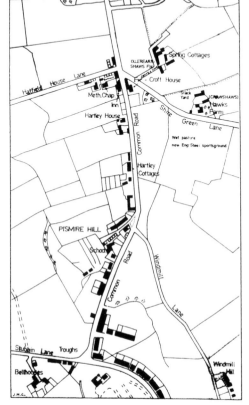

that the children listened spellbound to what I had to say. Then, when I repeated the question at the end of the talk, they enthusiastically shouted with one voice, 'Yeah', and I was bombarded with more questions. That made me decide to write the story of Shire Green, its people and its environs and to illustrate it with as many contemporary pictures as I could find. I also wanted to persuade the City Council to cherish the surviving local features and, in particular, to turn Lockwood's redundant farmhouse at the end of Oaks Lane, then used by the park-keepers in Concord Park, into a local studies centre. Sadly, the council refused. Such losses have made these books of reminiscences so much more important for posterity by identifying what has happened to an area where so many profound changes have taken place. Fortunately, it re-introduced me to Pat Jones, another former classmate, who helped me recall some half-forgotten aspects of our early lives and to show that even today, from the crest of the slope in Concord Park, one can still look northwards over Woolley Woods towards Keppel's Column and Wentworth, admiring the open scene which has changed little from previous centuries, although now it lacks the stone walls that used to edge the several fields. So to get to Shire Green, once I had arrived at Victoria station, I would walk along the stone-flagged passageway, past the Royal Victoria Hotel, until I reached the steps which would lead me down to the Wicker where I could wait for a tramcar to take me to Firth Park.

Shire Green (often known as Shiregreen nowadays) can be found relatively easily on most maps to the north of the city of Sheffield. It covers quite a large area but seemingly has no tangible boundaries.

There is a Shiregreen Lane, the redoubtable Shire Green Cricket Club, a Shiregreen Hotel, a Shiregreen Garage, a Shiregreen Cemetery and a Shiregreen Working Men's Club & Institute (where, not so long ago, the celebrated production of *The Full Monty* was staged). There is a Shiregreen School on the Shiregreen 'Flower Estate', which is partly in High Wincobank, and lately a Shiregreen Supermarket has appeared. The small Shire Green sub-post office closed in 1986. There has been a Shiregreen Congregational (now United Reform) Church since the 1930s, and there used to be a Shire Green Primitive Methodist Chapel until 1932/3 when, through the Methodist Union, it ceased to be 'Primitive'. In 1947 it changed its name to Hatfield House Lane Methodist Church. Throughout the last 170 years, especially since its close neighbour, the Horse Shoe inn, was pulled down in 2004, this church has remained the last direct link with a long and fascinating past and a strong focal point for community activities. Within its walls many of Shire Green's activities were nurtured, although many continued long after the old hamlets had been submerged under the massive developments of the 1920s and 1930s.

For this reason I would like to present another selection of old (and not-so-old) photographs and other illustrations telling the story of Shire Green's small church community, exploring its links with Wincobank and the surrounding district, and showing how it flourished and survived to celebrate its sesquicentenary.

Shire Green, made up as it was of a number of scattered settlements and situated on the brow and north side of Pismire Hill, was divided by the long common pasture between Upper and Lower (or Nether) Shire Green and traversed by the Common Road (now Bellhouse Road) which would take the traveller northwards to Thorpe and Wentworth. Perhaps it was this green common, long since shorn of trees, except for the three sets of 'Plumps' (clumps of tall trees) on the brow of the hill, which gave this area its name.

Where the Common Road (now Bellhouse Road) was crossed by the Brightside Road running from Southey (Eton Green) in the west to upper Wincobank in the east, stood a few dwellings and the Horse Shoe inn, which gradually became regarded as the centre of old Shire Green. Norman Gill, a former neighbour and local resident, used to say, 'If tha han't been born wi'in spitting distance o' Horse Shoe, tha aren't a real Shiregreener.' Well, now there's no 'Horse Shoe' to be born within sight of, I suppose there'll be no more real Shiregreeners!

Over the hill to the north, at the lower end of the Common, another string of farmhouses and buildings were recognised as Nether Shire (Green), while any buildings beyond, as far as the Hartley and Blackburn Brooks, were deemed to be located in Low Shire (Green).

At the southern end of the Wentworth Road, below the fork that led past the windmill towards town on Hinde House Lane, there was at the foot of Pismire Hill another small group of dwellings, farms and associated buildings on the Brush House Estate, known as 'Bell Houses'. From here the road turned sharply westwards into what used to be referred to locally as the Monkey Run or, more sedately, as Lovers' Lane but nowadays is Stubbin Lane, and ran towards the main turnpike road from Sheffield to Barnsley, then called Sheffield Lane. The imposing Brush House stood a little to the south, with the entrance to the ancient Crowder House directly across the road further to the west. Beyond the Crowder House Estate at Longley lay the hamlet of Southey, while further south were Fir Vale, Pits Moor and Burn Greave. To the east loomed Wincobank Hill, which was part-wooded with oak trees, and Wincobank Common separating High from Nether and Low Wincobank. In 1673 Harrison referred to 'Wincabanke' as the ridge or bank leading to 'Wincowe', leading up from Grimesthorpe towards the prehistoric hillfort at the top of the wooded hill.

For many centuries up to the start of the twentieth this part of South Yorkshire lay outside the growing Sheffield city boundary and formed the southern section of the historic great parish and township of Ecclesfield which was for a time partly administered by Wortley Rural District Council. In the Middle Ages Shire Green itself was part of the parish of Ecclesfield, next to the old bierlow of Brightside and a significant part of the Saxon shire of Hallam. It lay between Ecclesfield, which was the ecclesiastical centre, and Sheffield, a small market town at the confluence of several rivers and streams, with a castle that was the political centre of Hallamshire. Shire Green's location was recognised by the 'Plumps' which are said to have indicated the location of a neutral meeting-place. So what better place could there have been than here, between the two remaining 'Plumps', for the fine Hatfield House Lane Senior School to be opened in 1942 during the Second World War? As children, we watched it being built across the field from the Junior School as we carried out air raid drills by the underground shelters at the edge of our playgrounds. We occasionally attended performances there and more frequently had our teeth inspected and treated by Miss Woodcock and her dental staff. The school has lately been transmogrified into a reincarnation of the old Firth Park School with which it had been linked for several years. The former Grammar School known as 'The Brushes' or 'Redcaps', housed in an old historic stone-built mansion house, closed in 2003. It was then 'accidentally' burnt down. For many years it had been the only grammar school in the north of the city and was regarded with great affection.

As I used to return home in the evening, in the relative darkness of a poorly lit

Shire Green Lane, I would sometimes pause, especially if it were a cold and frosty night, and for a while stare up at the millions of stars sparkling in the inky black night sky over the park. It reminded me of the words of a poem by a remarkable sixteenth-century Spanish poet, Friar Luis of Leon, who wrote: '*Cuando contemplo el cielo de innumerables luces adornado, y miro hacia el suelo de noche rodeado, en sueño, y en olvido sepultado.*' (When I contemplate the heavens above adorned with countless lights and then turn my gaze upon the earth below all wrapped in the night, in slumber, and entombed in oblivion). My imagination for a while would travel back over the centuries to the countless people who lived in this area we now know as Shire Green, who worked, worshipped, loved and lived out their lives under these same constellations.

Near where I was standing, ancient Britons trod the path up to Winneca's Hill, where they built a fort and a long dyke across the valley towards Kimberworth. Here marched the Roman soldiers to their encampment on the hill. Here the oak forests had given way to grazing land, farms were created, and invading Angles and Saxons had settled down, giving us names like Butterthwaite and Thorpe, Osgathorpe, Skinnerthorpe, Reynathorpe and Grimesthorpe. 'Shyre Grene' (*scir-grene*: a sheared clearing) itself was created on either side of Pismire (= ant) Hill where the various tribal groupings in the area could gather, guided there by the clumps of tall trees at the summit. This clearing, later called Shire Green, eventually became the common around which people built their homes and worked the land. Gradually, to the east of the Plumps and at the southern end by the crossroads, a collection of simple buildings, farms, homes and workshops grew up, acquiring the names Oaks Fold and Upper Shire Green respectively. At the northern end of the common lay the long line of small homes and farm buildings called Nether Shire Green, and almost at the bottom of the hill was Low Shire Green.

Throughout the centuries, as men and women went about their daily lives, sometimes leaving for posterity their wills or their possessions, changes were taking place around them. Hamlets developed, large estates were created and then disappeared, leaving only indistinct traces of their former existence. Farmland became parkland or was lost under programmes of house building. Yet those same stars in the skies continued to bear witness to the passing of time and kept an eye on man's progress. If only they could reveal their secrets, what a story they might tell!

The antiquarian, genealogist and student of Sheffield's past, Joseph Hunter, used to live at Hatfield House which was thought to have originated as the farmstead of a Mr Hatfield from Doncaster. Others believed it was the home of Ralph Hatfield, who established in his will of 28 January 1625 the 'Dole', which was to be allocated through the parish church in Ecclesfield.

In 1819, when writing his *Hallamshire*, Joseph Hunter commented, 'The collection of materials for this work was begun at a very early period of the author's life. It was among the amusements of childhood and the chief pleasures of his youth. He has gone on increasing his store. He has spared neither time, nor labour, nor expense. He has been so fortunate as to meet with many persons who were both willing and able to assist him in his inquiries. That other evidence that might be made to bear on the subject of this volume he is not disposed to deny. But if something yet remains behind, it will be allowed that much is here brought together. And he

can truly say that what evidence has been presented to him he has faithfully used and faithfully exhibited.' The writer of this current volume would be gratified to think that the same might be said of the contributions in this collection.

While this is a book of reminiscences, it is not without reference to the general history of the area. It undoubtedly contains much that will appear of interest only to those who have some natural connection with the places and persons described. Nevertheless it is an important part of the much larger jigsaw of everyday social life in this small part of old Hallamshire in the south of Yorkshire. The pictures illustrate the stories better than the imagination, but often it is the background to the pictures where the details of the changes can best be seen. Of Shire Green and district there are many more pictures to be found and much remains yet to be told.

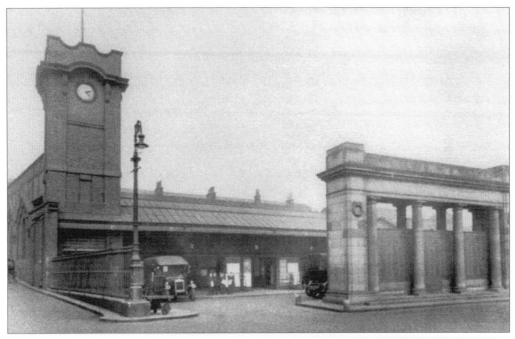

The former Great Central Victoria railway station about 1927 showing the First World War Memorial. Because the marble deteriorated, it was replaced by a bronze plaque in the 1930s and re-sited in the Booking Hall. In 1970 it was repositioned underneath the Wicker Arches and moved again in 2003 to a position outside the Royal Victoria Hotel. (Courtesy of Sheffield Local History Library)

Norman Gill at his grandson Peter's wedding at St Aidan's in City Road, 1995. He was an enthusiast for anything on wheels and used to love driving his Morris 8 and Triumph motorbike. Before a stroke in 1970, which left him paralysed and speechless, he used to drive for Weston Park Museum. He was fascinated by history, especially of Shire Green and Shiregreeners.

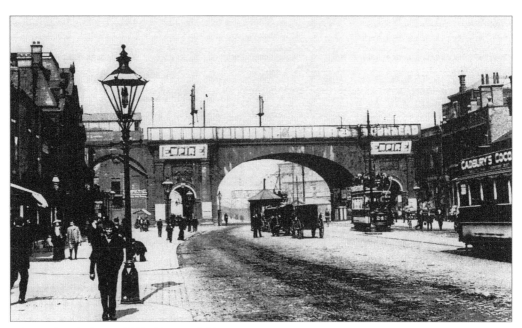

The Wicker Arches, c. 1912. Tramcar 243 was originally a single-deck car that entered service in 1904, converted to double-deck in 1911, became a fully enclosed car in the mid-1920s, was renumbered 294 in 1935 and again in 1938 to 335 before disposal in 1939. The single-deck car on the down line has Tudor Arch side windows similar to those on tramcar 46 at the Tramway Museum in Crich.

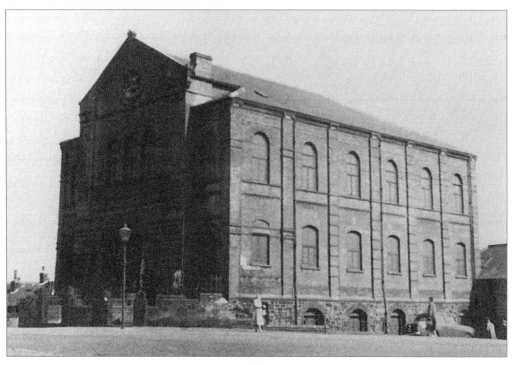

Petre Street Church in Ellesmere Road was built in 1868 but after a long life it was demolished and replaced by an old people's home. The members transferred to St Peter's which became a joint Anglican/ Methodist Church in a new circular building at Ellesmere.

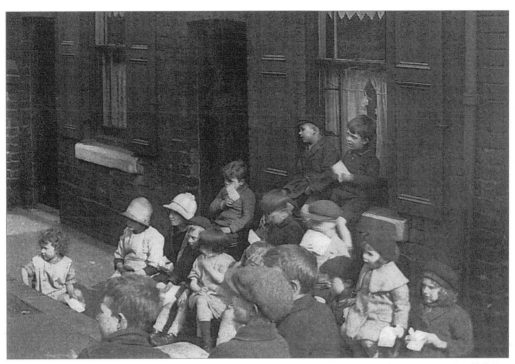

Joyce Manifold (in the light cape) with her older sister Nancy on her left. With other local children they are watching a 'yard and street concert' in Edgar Street, Pitsmoor, in 1926.

Joyce Brown née Manifold with husband, Vic, and a distant relative and friend, Mary Merchant (descended from Fanny Saunders) (right) in 1989.

The old turnpike, Pits Moor. The toll house was built in 1758 and was a double-duty toll bar because the road to Sheffield split here. One route continued to the left (east) down Burngreave Road; the other went to the right (west) via the steep Pye Bank. The toll house was reconstructed in 1836.

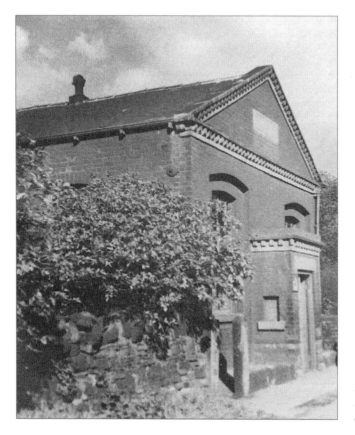

The little Crabtree Primitive Methodist Chapel in Crabtree Lane was built in 1865 and demolished in the 1970s.

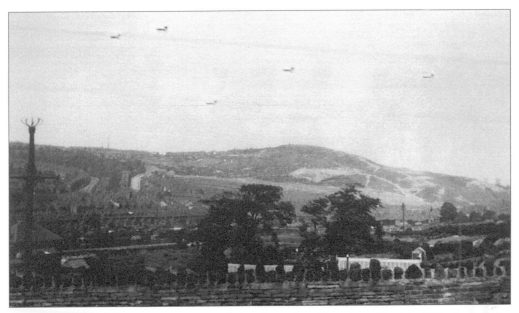

The southern aspect of Wincobank Hill over Grimesthorpe from Osgathorpe Road, in 1940, showing the several floating barrage ballons which were protecting Sheffield's industries from air attacks during the Second World War.

The house at 68 Osgathorpe Road, The Woodlands. It was from here that the photograph above was taken by a member of the Manifold family. The Manifolds later moved next door to No. 70.

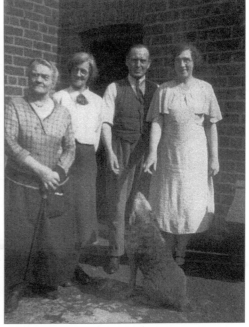

At the rear of no. 68 in 1935, several members of the Manifold family posed with their dog, Peggy. Left to right: Mrs Ann Hutchinson née Maycock and her daughter, Gladys; her son-in-law, Will Manifold, and his wife, Elizabeth Ann (Cissie), also Ann's daughter.

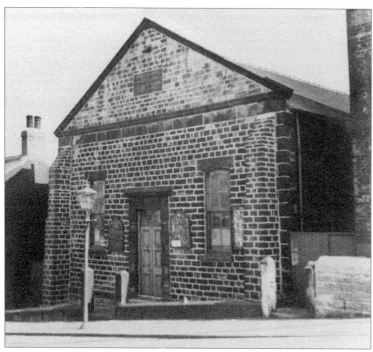

Grimesthorpe Road Church was built in 1870 near the Bowling Green pub, but this has been demolished.

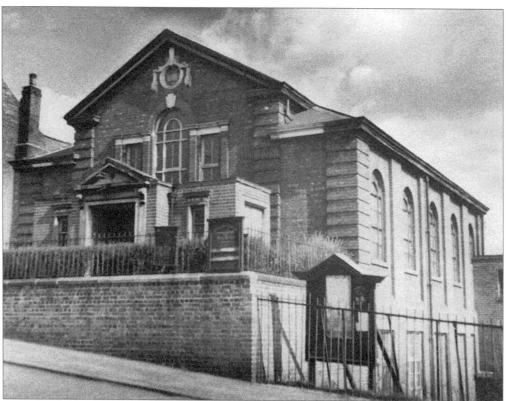

The Wesley Hall Church was erected in 1921 and stood almost opposite the Wesleyan Reform Chapel in Upwell Street. It has also been demolished.

Trinity Methodist Church, Firvale, was built in 1899 at the junction of Owler Lane, where this picture was taken, and the new Firth Park Road. It continues to thrive.

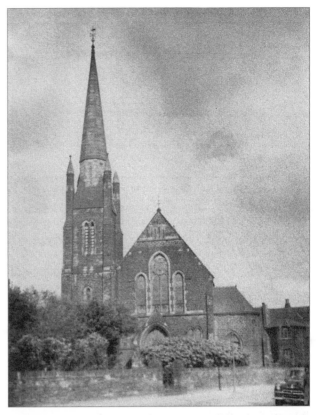

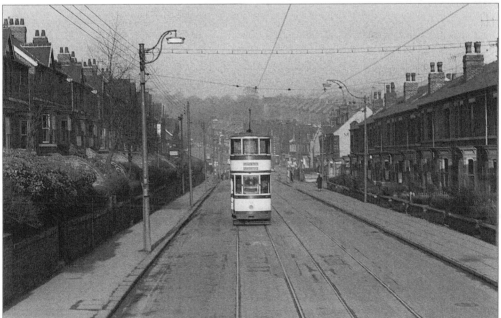

Tramcar 68 travelling along Firth Park Road in about 1950 on its way towards the Firth Park terminus beyond Page Hall Road and the junction with the tram routes to Attercliffe and Brightside. In the distance is Brush House Wood opposite Firth Park.

1

IN THE BEGINNING

Although the history of Shire Green and its people can be traced much further back, this story begins some forty years after the union of the English and Scottish parliaments under Queen Anne in 1707. In the tiny scattered farmsteads and hamlets that made up the vast ancient parish of Ecclesfield, life was more governed by the seasons, by the parish church calendar, by taxes, tithes and pew rents, and by the need to make ends meet, rather than by general Acts of Parliament. Nevertheless, some Acts did affect almost the whole country. The Hearth Tax, for example, introduced in 1662, took its toll of 2 shillings per hearth in properties worth 20 shillings or more per annum. It was abolished in 1669 and replaced in 1696 by the Window Tax, at 2 shillings per window, and this tax wasn't repealed until 1851! The second Enclosure Act of 1845 was to put more land in our area of interest into the ownership of the Duke of Norfolk, who already possessed a lot of the land, as did the Earl of Effingham and the Earl Fitzwilliam. Some land was still in the hands of the Church, while some small estates were in the ownership of petty land-owners such as the Wilkinsons of Crowder House, the Booths of Brush House and the Smiths of Barnes Hall. A little land was in the hands of a few independent farmers, one of whom, possibly a McGregor or Gregory, had built Gregg House.

The medieval strip field system of farming could be observed in the parish fields (and may still be traced in one or two of the long gardens north of Hartley Brook). Regular hunts used to take place over much of the open countryside, from Crowder and Brush Houses northwards to Wentworth, where the natural contours and obstacles were much appreciated by the participants. Everybody took part, the Earl Fitzwilliam and his guests on horseback and the local population on foot, but all enjoyed a sporting day out.

To the east of the Pennines and just north of the little township of Sheffield, on the old packhorse track from Southey to Wincobank Hill top, stood an old farmstead in the now forgotten little hamlet of Reynathorpe. Here an old mortar cannon had been acquired, so tradition had it, to be fired to warn the local population during these perilous times of the approach of any danger, particularly from bands of marauding troops coming down from the north. The cannon was mounted on a four-wheel trolley and located in the farmyard of the eastern part of Hatfield House farm whose cruck barn dated back to about AD 1100. It was unfortunate that this piece of historic artillery was taken for salvage in the early days of the 1940s' war effort.

William Ellis, the last working owner of this farm, said he could trace his family tree back to the time of Elizabeth I, although his original 1611 copy of the King James's Authorised Version of the Bible which might have contained much information to support this claim, had several of its front pages missing.

Not far away, on 17 June 1703 John Wesley was born into the large family of an obscure parson in Epworth in Lincolnshire. The family came from a long line of dissenting clerics but John was destined to have, along with his brother Charles, a great and lasting effect on the social, religious and political life of the country. When he was one year old John was rescued at the last moment from the upper floor of the burning rectory – 'A brand plucked from the burning' as he later described it – and from then on his mother Sarah was convinced that he must have a special calling in life.

John and Charles Wesley both went to Oxford University and eventually became ministers in the established Anglican Church. John was a prim and grim High Church man but, despite his disciplined habits and his preaching, he felt he had failed in his ministry by touching no consciences and warming no hearts, particularly in America. At university his group of friends, because of their methodical habits, had been sneeringly called 'Methodists' and this nickname stuck when, after their conversion, John began to go out preaching salvation in churches when he was permitted to do so, or in the open air when he was not. He was aided by the catchy songs and inspiring hymns composed by his brother Charles which contrasted markedly with the droning of the psalms and prayers in the parish churches. Thus Methodism was 'born on song!' and was accompanied by fervent preaching of a simple message.

In the large parish of Ecclesfield, the church began to take on some secular functions in addition to its religious duties. Great changes came about in the eighteenth century when most of the gentry families moved away, immigrant families moved in and the population began to depend less on agriculture for a living and more on industry. At this time the Church of England was generally failing to meet the new social challenge posed by this because many Anglican clergymen had allowed themselves to identify with the gentry and to forget their calling in favour of an easy-going way of life. Nevertheless, they became alarmed at the popularity among the rural and urban industrial classes of John's fearless preaching of the simple, direct and convincing message about the Love of God, inward holiness and the need for repentance. It was generally a violent and morally corrupt age, full of extremes in riches and poverty, John and his Methodist followers were the first to speak out strongly about the decadence within the Established Church and the brutishness of ordinary life. In attracting many to hear their preaching, the Methodists were also frequently attacked by angry mobs.

John Wesley believed that 'the whole world was his parish' and he began to travel on foot or on horseback over the turnpike roads and lanes of the country preaching his message wherever he found people to listen to him. In 1744, the same year that milestones became compulsory on turnpiked roads, he was in Cheshire but by 1746 he had visited Lancashire, Staffordshire, Derbyshire and parts of Yorkshire, riding 30 to 40 miles a day, preaching three to four times daily, and all at a time when Charles Edward Stuart, the Young Pretender, at the head of a Scottish army had been invading England and covering some of the same ground.

From 1739, when the foundation stone of the first 'New Room' for preaching in had been laid in Bristol, more and more buildings were erected as Methodist societies grew in number. First of all they had to be licensed as 'preaching places' under the Act of Toleration as dissenting (from the Church of England) chapels, although both John and Charles remained ordained clergymen of the Established Church for the rest of their lives.

John Wesley's first visit to Sheffield took place in 1742. In the previous year a small Methodist chapel had been built in Pinstone Lane, Sheffield, although it was destroyed by the mob the year after John's visit. Another little chapel in Union Street was also repeatedly attacked by the mob but by 1764, when a new chapel was built in Norfolk Street, attitudes had changed sufficiently to allow an even larger one to be built on the site in 1780, which John Wesley himself opened. (In 1908 it was replaced by the present Victoria Hall.) In these forty years the population of the town had increased from twelve thousand to twenty-five thousand, and was still growing.

It took a while longer for dissenting chapels to be erected in the countryside around Sheffield even though the Methodist itinerant and local preachers were working tirelessly. Other groups, like the Calvinists, were already spreading the message. In 1748 John Wesley visited Thorpe Hesley and preached from some stone steps in Thorpe Street on his way to Sheffield. The journey was re-enacted in 1988, marking the 250th anniversary of Wesley's conversion in 1738, when a suitably clad horseback rider travelled to Sheffield via Shire Green.

In all, John Wesley paid some thirty-five visits to Sheffield, attracting large crowds of people, as in Paradise Square in 1779, to see and hear him preach. Those people who were inspired by his words and songs would form small house groups or classes and make modest collections towards the building of a small 'preaching place'. Although large numbers of people were moved to join the new Methodist societies, having been attracted by John Wesley's stirring words of assurance – and he was particularly good with children – there was also a drop-out from these new groups after a year or so. Perhaps the Methodist regime was too demanding. The Established Church, however, still retained many of its adherents and people were still christened, married and buried according to its rites, although its congregations had been seriously affected by the growth of Methodism. John Wesley's preaching and Charles Wesley's repertoire of new hymns had an enormous effect on both the spiritual and everyday life of many people at a time when events in the world abroad, motivated by the spirit of the new rational philosophy, as advocated in the pamphlets of Thomas Paine, were having a disturbing effect on rich and poor alike. Within the parish of Ecclesfield, Methodist chapels were established at Loundside in 1806 and on the former village green in 1817. By the end of the eighteenth century, there had been a revolution in France which had established a repressive republic. In Britain, much revolutionary activity was turned into an industrial revolution. Wesley wanted to save souls. Instead of the French slogans of 'Liberty, Equality, Fraternity' he proclaimed 'Piety, Probity and Respectability' which he thought would create a better society.

John Wesley died in London on 2 March 1791, having already put the responsibility for the running of his new church into the hands of the Methodist Conference. The philosophy of his life may be summed up in the words on his personal seal, 'BELIEVE – LOVE – OBEY'.

Into Sheffield the following year, in answer to an advertisement in the *Sheffield Register*, came an earnest 21-year-old Scottish Protestant of the Moravian Brotherhood. James Montgomery had been educated at Fulneck, the Moravian settlement and school near Pudsey, and enjoyed writing poetry. Once, when in Wentworth, he encountered the Earl Fitzwilliam out riding in the park, and showed him one of his poems. The earl, impressed, gave him a golden guinea for it. Montgomery became clerk to the *Register*'s editor, Mr Gales, but two years later,

when Mr Gales had to flee the country on account of his forceful revolutionary views, he became editor himself and renamed it the *Iris*. He remained its much-respected editor until 1825. In 1835 he was given an annual pension of £150 by Prime Minister Sir Robert Peel, who had created the Metropolitan Police Force and would later repeal the pernicious Corn Laws.

Like John Wesley before him, James Montgomery advocated popular education and became one of the original subscribers to the large National Lancasterian school in Carver Street, Sheffield, which followed Joseph Lancaster's monitorial system and which proclaimed on its inscription, 'Built by Subscription 1812'. He was also a great believer in the work of the Sunday Schools in which he used to teach. He was a friend of George Bennett, who in 1812 originated the Sheffield Sunday School Union. James was a good poet and for the SSSU's annual Whitsuntide Gatherings he composed a number of hymns, many of which are still sung today. In the pages of the *Iris* he denounced the slave trade. He was considered to be the 'conscience of the town' and because of his standing he was often a welcome guest of Mrs Mary Ann Rawson at Wincobank Hall. Her equally philanthropic unmarried younger sister Miss Emily Read wanted to start a Day School next door to their Undenominational Chapel close by the Hall. James Montgomery not only opened it in 1846 but also wrote some verses for the occasion, just nine years after a little Wesleyan chapel had opened its doors less than a mile away in Upper Shire Green and some thirty years before the Universal Elementary Education Act was passed in 1876. The purposeful nurturing of young minds and healthy bodies was a very important aspect of their philosophy as could be seen when Mrs Rawson and her sister prevented the 'Stone House', being built at the top of Leedham Road opposite the brick fields belonging to Wincobank Brick Works in Shire Green Lane, from becoming a public house! The final separation of the Methodists from the Church of England happened very quickly but not fast enough for some Methodists who felt themselves remote from the sober and solemn ways of Mother Church. Alexander Kilham set up the Methodist New Connexion in 1797. Elsewhere there were other Methodists like Hugh Bourne and John Clowes in whom the old rebellious evangelistic spirit smouldered on. Hugh Bourne was a great preacher but, like Wesley before him, he was anxious to reach ordinary people. After having heard that revivalist outdoor gatherings called 'Camp Meetings' were being held with great success in America, he resolved to imitate them at home. The first such meeting was held on Mow Cop in Cheshire on 31 May 1807 and was well attended. John Clowes, a speaker at that meeting, decided to form a new 'Society of The Primitive Methodists' on 13 February 1812. They were deeply concerned to preserve the Methodist spirit and when James Crowfoot affirmed, 'If you have deviated from the old usages, I have not. I still remain a primitive Methodist,' he was simply voicing what was in accord with the genius and spirit of John Wesley and the early Methodists.

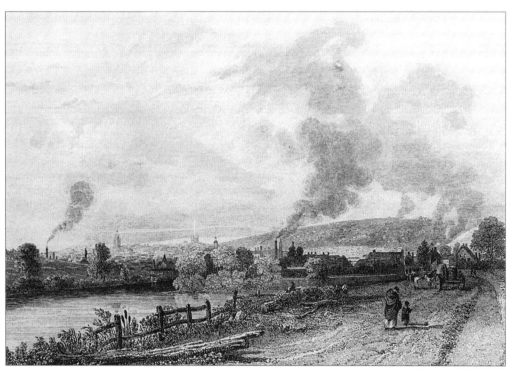

Eighteenth-century Sheffield from the Attercliffe Road below Burn Greave and Pits Moor, with the River Don on the left, showing the sort of roads that Wesley and other travellers would have used.

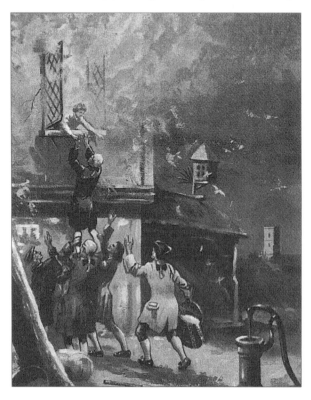

An artist's impression of the young John Wesley being plucked from the burning rectory in 1704.

John Wesley walked, rode on horseback or (later) travelled in his own horse-drawn carriage as he moved around the country spreading the Gospel message. This equestrian statue was erected in Bristol in 1933 in front of the stable near the first 'preaching place'.

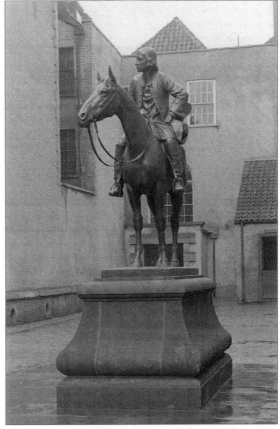

Thorpe Street, Thorpe Hesley, where John Wesley preached in the open air.

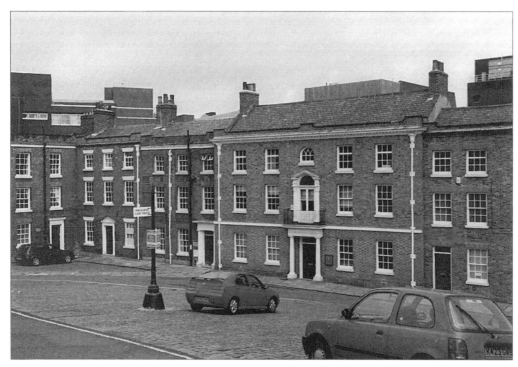

Paradise Square, Sheffield, where John Wesley preached to 'the largest congregation I ever saw on a weekday', as he remarked in his 1779 Journal.

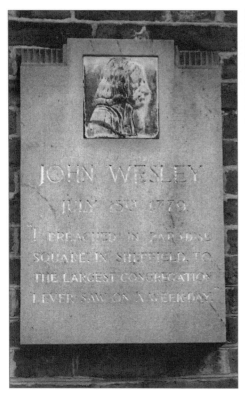

Above: *Taken from Hugh Bourne's* Journal, *it records that on Thursday 13 February 1812 the Primitive Methodists Society was officially formed.*

Left: *The plaque in Paradise Square commemorating the great event of 15 July 1779.*

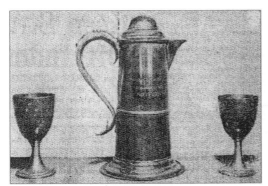

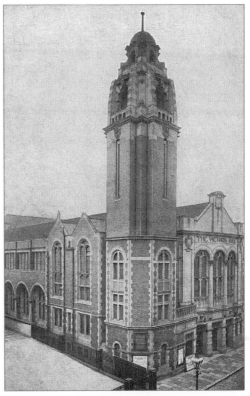

Above: *Carefully preserved in the Victoria Hall is an interesting link with early Methodism. It is a set of old communion vessels made in Britannia metal and probably produced by James Vickers, its inventor. James became a Methodist in 1763. He was also the son-in-law of Mr and Mrs Holy, with whom John Wesley stayed when he visited Sheffield.*
Right: *The Methodists' Victoria Hall was built in 1908 on the site of the former Norfolk Street Chapel.*

A chapel walk passing the Victoria Hall and the Chapel Walk. In the foreground are Velma Furniss and Kath Rhodes, with scholars on a Sunday School outing.

In 1988 John Wesley's ride from Thorpe to Sheffield via Shire Green was re-enacted to commemorate the 250th anniversary of his conversion.

2
SHIRE GREEN OVER 150 YEARS AGO

In 1828 John Blackwell published *The Sheffield Directory and Guide* from his printing office in the High Street. As well as detailing the town's history, it included information on the merchants and principal inhabitants of the town and described the neighbouring townships and villages to the north including Ecclesfield and Grenoside, Shire Green and Wincobank, Blackburn and Kimberworth Hill Top, all significant places at the turn of the nineteenth century. Thus a copy fell into the hands of the Ellis/Maycock family because what went on in the booming town of Sheffield was of more than passing interest to the surrounding communities.

Before 1818 there had been many complaints about the state of the town of Sheffield. Its buildings had become both unsightly and disproportionate, largely thanks to unscrupulous individuals who were not averse to 'acquiring' parts of the footpaths for the capricious erection of new properties – footpaths that were already narrow and unsuitable, in streets that were dirty and crowded with animals, carriages and carts, in a town that was poorly lit and badly policed. The Police Act of 1818 did little to remedy this building problem although, assisted by the Act of Parliament for the incorporation of the Gas Light Company in the same year, it did make the town's main streets much safer. Nevertheless the flaws in the provisions of the Police Act still left people complaining about 'nocturnal disorders and overt vice'. Yet the town of Sheffield was making rapid strides in commercial enterprise and 'moral improvement' and in expanding its suburbs.

For the Anglicans in the town there was the old-established parish church of St Peter with more churches being built as the population grew. By the turn of the eighteenth century the Quakers, Baptists and Catholics (especially after Catholic Emancipation in 1829) had all built their own meeting-places or churches. The dissenters from the rites of the Church of England, the Independents and the Methodists ('Wesleyans' after 1812) had long been setting up their own chapels, and by 1828 the little chapel in Coal Pit Lane (later Cambridge Street) was being rented and occupied by members of the new 'Primitive' Methodist Connexion.

Lack of adequate sanitation led to a serious outbreak of cholera in 1832. It had a devastating effect upon the population, killing almost a third of those infected, even though a new reservoir had been built at Redmires by the newly incorporated Sheffield Waterworks and despite the many other improvements being made.

In 1833, just before the little chapel was built at Shire Green, another Directory said that the principal residents and trades people of (Upper) Shire Green were Thomas Finch, who ran the Day School (presumably the one on Bellhouse Road); the Misses Garside; Samuel Gillott, hat manufacturer; Matthew Nelson, stonemason;

Jacob Nicholson, butcher; Mary Oxspring, the licensed victualler of the Seven Stars public house off Oaks Lane, and Christopher Stevenson, who ran the Horse Shoe on the corner of the Common and Brightside Roads (later Bellhouse Road and Hatfield House Lane). There were three boot and shoe-makers, S. Blackhurst, James Butler and William Thacker, and only three farmers are mentioned, Michael Berry, William Moorwood and Thomas Parker. By comparison there were twenty fork-makers: Joseph Barker; Jonathan Bradley; Joseph Chaloner; Stephen Chaloner; Samuel Dawson; Joseph Ellis; Marmaduke Ellis; William Ellis; Joseph Firth; Joseph Gregory; Jonathan Haslehurst; William Hodgson; William Howson; John Kay; Samuel Oxspring; Isaac Platts; Joseph Platts; Robert Platts; William Platts and George Rhodes. At Nether Shire was George Beard's Dog and Gun public house, and other important tradesmen there included John Judge, pen-knife and pocket-knife manufacturer; Joseph Nicholson, maltster and farmer; two other farmers, William Stenton and Rupert (or Robert) Walker; and four fork-makers, J. and W. Beardshaw, George Tingle and George Wright. The neighbouring hamlets of Shire Green and Nether Shire formed the principal area for the manufacture of table forks for the cutlery business in Sheffield and district, yet the work went largely unsung in the annals of cutlery manufacture.

Shire House, a large and pleasant mansion at Nether Shire, was at this time the seat of Richard Greaves of the Sheaf Works, which, as William Greaves & Sons, had been the first real factory for the manufacture of cutlery in Sheffield. Built in 1823, it employed scores of workmen and 'outworkers', many of whom would have been Greaves' immediate neighbours.

Not far away at Four Lane Ends (Sheffield Lane Top) lived Aaron Ashton, landlord of the Pheasant, as well as William Calver, Moses Charlesworth and Thomas Eyre, shoemaker. At Cliff House on Elm Lane lived William Smith, solicitor (of the Smiths of Barnes Hall, and precursor of the Wake Smith Partnership of Sheffield solicitors). At Brush Houses were Mr John Roebuck and M.A. Roebuck, with A. Spilling at the Ladies' Boarding Academy, and Edward Wright, farmer. There seem to be several omissions from this Directory, including the little nameless 'beer house' by Watkins' farm on Pear Tree Lane off Bellhouse Road. One can only surmise that such folk did not qualify either by their standing or by their calling, although some of the missing names appeared in the 1828 Directory. Isaac Platts of Shire Green will appear again in 1851, when he acquired the lease on the Shire Green chapel property.

Until the early twentieth century Wincobank Hill was heavily wooded, particularly on its southern slopes. It was gradually denuded throughout most of that century until benign neglect allowed Winco Wood to reassert itself. The hill was subjected to housing development except at the very top, which was gifted to the town by the Duke of Norfolk. Ebenezer Elliott, the 'Corn Law Rhymer', so called for his support of Cobden and Bright, mentioned the oak trees of Wincobank in his poem, 'The Ranter', written in 1833. He lived in Rotherham although it has been alleged that he occupied Fir Croft Cottage for a while.

> *The birds on cloud-left Osgathorpe awake;*
> *And Wincobank is waving all his trees*
> *O'er subject towns, and farms, and villages,*
> *And gleaming streams, and wood, and waterfalls,*

Up! Climb the oak-crowned summit! Hoober Stand
And Keppel's Pillar gaze on Wentworth's halls
And misty lakes, that brighten and expand,
And distant hills, that watch the western strand.

By the end of the twentieth century Sheffield Town Hall had removed all vestiges of the sixteenth-century cottages and of the nineteenth-century Parkyn Jepson Tower, commonly called Wincobank Castle. The old Wincobank Hall below the western brow of the hill was demolished in the 1920s and its estate and much farmland at High Wincobank and Shire Green was given over to the new Shire Green Model Housing Estate known as the Flower Estate because so many of its streets were named after flowers.

There is an interesting relationship between Upper Shire Green and High Wincobank in terms of where and how they overlap. For example, the Shire Green housing estate and its two schools are largely in High Wincobank, yet they are considered to be in Shire Green. Another area that led to confusion was at Low Wincobank, particularly the farmland on the Sheffield side of the Blackburn Brook valley and Meadow Hall on the Rotherham side. As this latter area became heavily industrialised, pressure was put upon the small village to provide housing accommodation for the influx of workers. Low Wincobank at this time was not actually in Sheffield but in the parish of Ecclesfield, but by the time the provisions of the 'Meadow Hall Land Society 1875' were well under way, the area had become incorporated into Sheffield with the consequent need to alter many of the existing street names. Hence one was able to see such awkward street names as 'Jedburgh Street late Johnson Street'. Fowler Street became Fife Street, Station Road became Standon Road, Malthouse Lane became Merton Lane and Bardwell Road became Barrow Road. Wincobank grew into a thriving semi-rural/semi-industrial community. A Primitive Methodist chapel was built on Barrow Road in 1874, St Thomas's Church of England on Newman Road and a small Congregational chapel on Merton Lane behind the Wincobank Hotel. The Maycocks had become involved in the work of the little Methodist church on Barrow Road since their earlier move from Northamptonshire to Kimberworth and thence to the butcher's shop on Barrow Road.

On the other side of the valley another Methodist church was built in Blackburn Road. This, along with the neighbouring houses and the Meadow Hall farmstead at the foot of Kimberworth Hill, was demolished in the 1960s and 1970s to make way for the Tinsley Viaduct and Junction 34 on the M1.

The shortest routes to Low Wincobank from Shire Green were not by road but by two footpaths. One led across the fields from Oaks Lane to the top of the first clough (just above the original golf links), into the second clough and alongside the tiny stream into Woolley Wood and thence into Station (Standon) Road via Woodbury Road. The other path led past the pond to the left of Hawke's Farm, down Shire Green Lane and alongside a stone wall to the top of the slope that meandered all the way down to the 'Twitchels' and the top field of Maycock's farm. I'm not sure exactly when the Maycocks moved to the new farm premises at the Fife Street junction with Jedburgh Street. It was part of the Meadow Hall Land Society's grand plan, and probably took place after the Midland Railway acquired their property in Barrow

Road in 1892 in order to build a railway bridge over lower Fife Street as part of their construction of a rival to the Manchester, Sheffield & Lincolnshire Railway.

In 1837 a young Queen Victoria ascended the throne and a group of people in Shire Green decided to build a small Wesleyan Methodist chapel behind the Horse Shoe on 'a certain highway leading from Southey to Wincobank'. In the following year, in spacious grounds in Glossop Road, the Wesleyans built their Wesley College, which lasted until 1906 when the Corporation renamed it King Edward VII School. The 1830s had seen the rapid development of the railways. Communications were further enhanced in 1840 by the introduction of the Penny Post, but those years were regarded as the 'hungry thirties and forties' when the agricultural weekly wage was only 10 shillings and many people had only a shilling a week – the price of a loaf of bread – to live on. Sir Robert Peel finally abolished the Corn Laws in 1846. When the Victorian Age began people were governed by daylight and the seasons and had relatively limited horizons, but by the end of the nineteenth century the power of steam and rapid industrialisation, the enthusiasm for speed and the railways, the miraculous inventions of the telegraph in 1840 and the telephone in 1876, and the massive growth of the population and commerce had all resulted in so many changes that earlier attitudes to time and regulation had to be modified. Out went 'St Monday' when no work was done. It was replaced by a half-day's work on Saturday as compensation. Time was standardised for the whole country and 'clocking-on' machines were introduced into factories in 1885. Many people tried to improve their lot by attending evening classes at Mechanics' Institutes and Methodism became increasingly popular because it fitted the ethos of the times.

In the 1956 Centenary Souvenir of the Methodist Church on Hatfield House Lane the Revd William Leary wrote: 'Shiregreen, as we know it, is comparatively new. It grew from a small village in the parish of Ecclesfield to a city suburb in the short space of twenty-five years and all the changes took place between the two world wars.' He remarked that the 'village' at Shire Green proper could have centred on the little group of old cottages and farm buildings in the Oaks Fold area, where once 'Oakes ffarme' stood on the site of the ancient Woolley Grange. This was part of the old Woolley estate, of which only Woolley Woods now remain. Many years ago, near the 'Plumps', this area saw the beginnings of an Anglo-Saxon village, surrounded by tall trees and vast fields which are today covered by council houses, streets and parks. The fields stretched down into what is called Low Shire Green towards the valley, with a few scattered farmsteads and famous old houses such as Gregg House, Ivy House, Shire House and Low House. Looking across this lovely country towards Ecclesfield and beyond, one could never have imagined that such wide open spaces would so soon be transformed into the vast housing estate it has become.

Down Shire Green Lane was the extensive Hawke's farm, whose fields covered an area which included the present Shire Green Cemetery as well as reaching the grounds of Woolley House in lower Wincobank. Latterly the land was farmed by the Crawshaws before Concord Park was created. Nearby on Jacob's Lane was a subsidiary farm run by the Ollerenshaws, which on one map was called Hawke's Fold. It is interesting to speculate whether 'Hawkes' is a corruption of 'Oakes'.

The Bell House Road, which runs through the heart of Shire Green, was once called Common Road and before that Wentworth Road. It extended from Windmill Lane to Beck Road. At Beck Road it forked, Beck Lane going west and Deep Lane

carrying straight on towards Thorpe. Low House Farm stood on the west side not far from the fork. Nethershire Lane was in existence a hundred and more years ago, and over on its north side stood Ivy House and Shire House. Part of the present Sicey Avenue, then called Sicey's Lane, was little more than a bridle path which ran from Sicey Ellis's farm at the end of Nethershire Lane up the hill to Hatfield House Lane, to the easternmost of the three parts of the old Hatfield Houses where he lived. In front of them was the lane linking the crossroads at Common Road with the crossroads at the top of Sheffield Lane. Sheffield Lane is now the Barnsley Road and remains the main road either to town or into Ecclesfield and beyond.

A map of 1854 shows houses in Oaks Lane and Oaks Fold in which the old Shiregreeners lived. They form an interesting company. There was John Clark, shoemaker, and Charles Machen, tailor; Henry Pinder was a pocket-knife manufacturer and Joseph Walton a wheelwright. Thomas Hawke and William Kemp were farmers, while Henry Greaves farmed at Hatfield House and Joseph Moulson at the Bell Houses at the southerly foot of Pismire Hill. There were more farmers in Nether Shire. The fork makers, the trade for which Shire Green was noted, made up quite a large proportion of the community and the names of many are still remembered, including James Barnes, Joseph Beardshaw, Edward Challoner, Thomas and William Ellis, the Nobles, the Oxsprings, William and Isaac Platts and the Rhodes. At the Bellhouses were John and Joseph Gregory.

A few people today still remember the Shire Green Endowed Free School opposite the corner of Windmill Lane, its site occupied first by a dry cleaning laundry and now by a freezer centre. There were numerous wells, especially in Low Shire. Shire Green's northern boundary was marked by Cricket Lane with Cricket House, Market Lane off Grange Lane, Butterthwaite wheel and dam down in the valley, Hartley Brook and Blackburn Brook in the bottom. Despite the passage of time it is still possible, if one is careful, to follow this line and imagine what Shire Green was like for hundreds of years until the 1930s. The people of that period are perpetuated in the names of people and places today, and the roots of not a few of the present inhabitants run deep into the past.

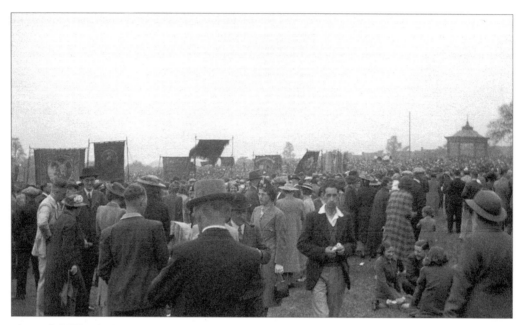

A crowded Whit Gathering in Firth Park, c. 1939. The original bandstand which was later demolished can be seen on the extreme right.

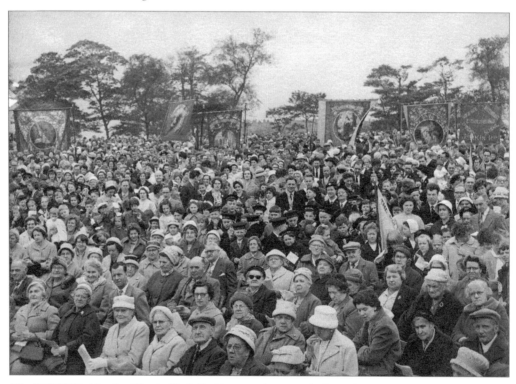

The 1959 Whit Monday Sing in Firth Park's natural arena. At the gathering are the members of many Sunday Schools identified by their colourful banners. They include Hatfield House Lane Methodists, Brightside Methodists, Low Shiregreen Methodists from Beck Road, Southey Green Baptists, Jenkin Road Methodists and many more.

Hatfield House Lane's Sunday School Queen for 1959/60, Diane Dowker, in front of her banner, with Derek Cadman (left) and friends.

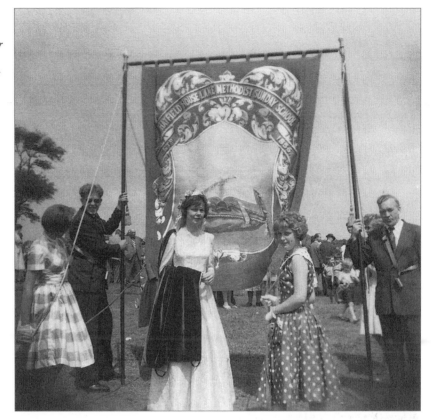

A postcard of Firth Park, 1937. On the reverse is a message from H. Wilson requesting Mrs Cooper's permission to take her daughter Eileen out the following afternoon.

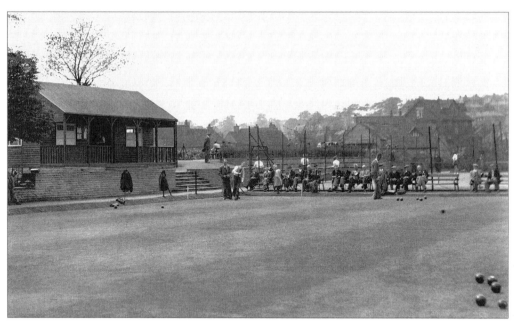

Freddie Kenyon had a series of quality postcards made for his shop on Bellhouse Road. This one shows the bowling greens and tennis courts at the entrance to Firth Park in 1950. At the rear are the old farm buildings. The land belonging to this farm was acquired by Mark Firth in the year he was Mayor of Sheffield and the park was created in 1875, thus giving a new name to the area once called Bell Houses.

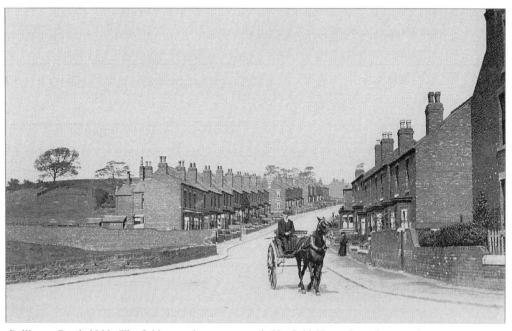

Bellhouse Road, 1910. The fields stretch away towards Hatfield House Lane but new houses on Bellhouse Road from above the North Quadrant can already be seen behind the stone wall of the field on the left.

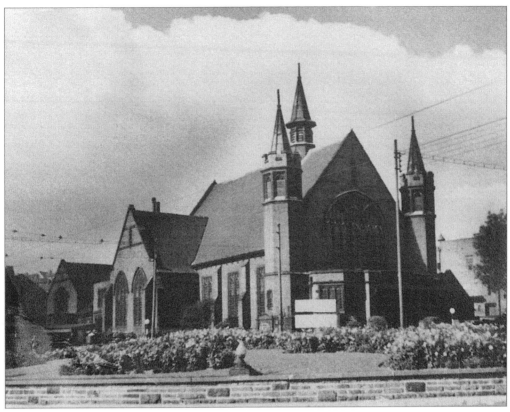

Firth Park United Methodist Church, 1950. Built in 1911, this splendid church stood at the junction of Sicey Avenue with Stubbin Lane.

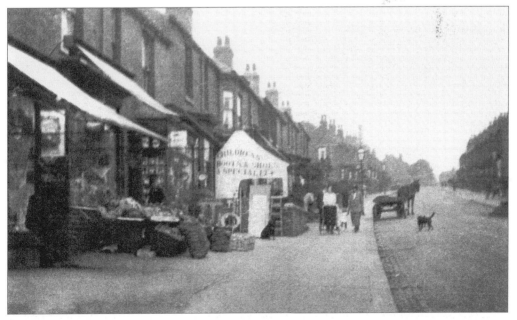

By the 1920s several shops had appeared on lower Bellhouse Road below the North Quadrant.

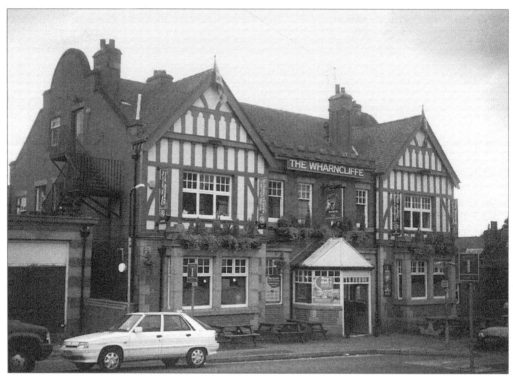

The Wharncliffe public house on Beavercotes Road boasted a substantial dance hall in the basement. Mrs France, who used to live on Horninglow Road and went to school at Hucklow Road, remembers going to this dance hall with her older sister Mabel in the late 1940s and '50s when she should have been attending the weekly Thursday meeting of Home Fire Girls at Firth Park Church. Her dad was not best pleased when he found out but her mother talked him round, as mothers do. Her daughter Pauline used to attend Velma Furniss's dancing school on Oaks Lane.

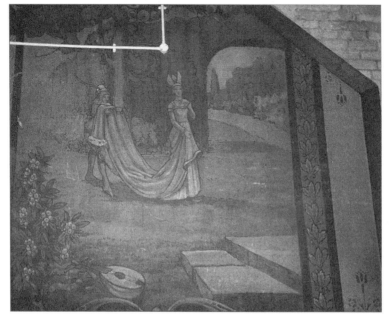

Despite falling into disuse as a dance hall and becoming a general storeroom, the side walls of the Wharncliffe's ballroom are still covered with handsome canvas-backed paintings of a romantic nature, produced by an unknown artist. Some are badly damaged as, unfortunately, are the murals painted on the end walls. However, they all still evoke the atmosphere of a once-happy place where young people went to enjoy themselves.

The 'Welfare' was the clinic on the North Quadrant. It looked after the needs of children and the elderly. It was here during the war that one went with one's mother to collect a medicine-bottle ration of concentrated orange juice to make sure children got a good dose of Vitamin C. As we grew older we complained that we were 'too old for orange juice and too young to smoke'!

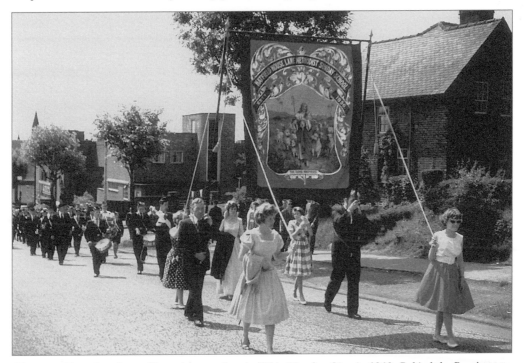

Homeward bound up lower Sicey Avenue after the Whit Monday Sing in 1960. Behind the Boys' Brigade Band can be seen the doctor's surgery above the former Paragon cinema. This later became the site of a new Co-op store, with a supermarket alongside and a bowling alley to the rear.

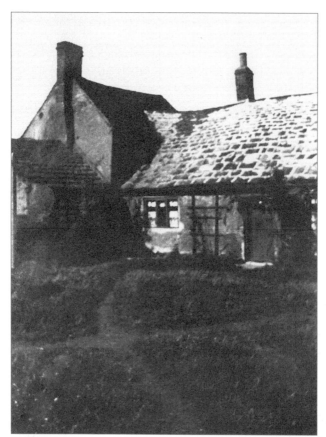

Riley's Farm cottages were located on the Brush House estate on the south side of Stubbin Lane, to the rear of the two current large blocks of shops and flats.

Below: *On Barnsley Road just below Crowland Road is part of the old stone wall entrance to Crowder House. It is all that remains of this former ancient estate, although at one time the old roadway could be seen alongside several back gardens. The entrance has been subjected to vandalism and another small landmark is slowly disappearing.*

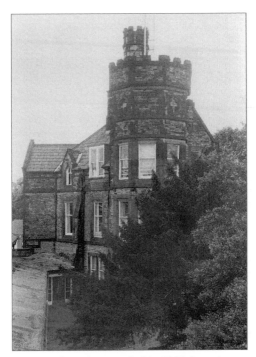

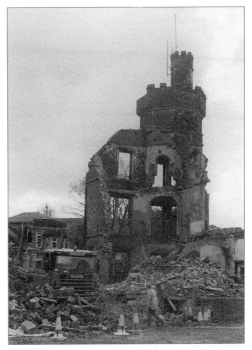

The Brushes, photographed in 1967 from the grassed garden in front of the Library Wing and looking towards the tower. At this time the building was still a school.

The remains of Brush House tower after the arson attacks of 2003 during the firemen's strike.

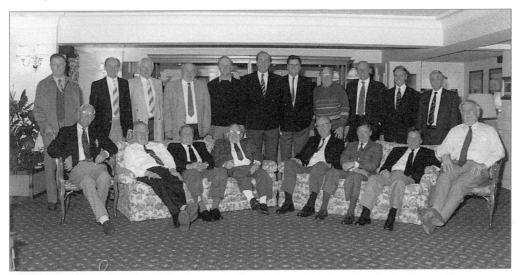

Firth Park Grammar School Old Boys from the 1944 Summer Harvest Camp at Careby, Lincolnshire, at a reunion in the Beauchief Hotel. Back row, left to right: Ron Elwis, Eric Stenton, Malcolm Ayton, Brian Baverstock, Mick Leeson, Brian Hall, Derek Foulger, Brian Kirk, Dick Martin, Brian Moore, Tony Ryan. Front row: Norman Marvin, Barry Collins, John Lovell, Peter Jubb, Les Rogers, Roy Swallow, Derek Wragg and John Ball (in the chair). The Old Boys have two reunions a year and the numbers are growing as new members from other years join in. They have salvaged the War Memorial and the Honours Boards but still deeply regret the loss of the historic school building.

Longley Bridge at the foot of Longley Lane, looking up the hill towards the Brushes. Longley Park was later created on the left from the estate of Crowder House.

Right: Brenda Jackson at the Longley Park open air swimming pool in May 1957 and yes, she did go in the pool which was always freezing, she recalls. Brenda lived on Bellhouse Road from 1943, next door to Eddie Roberts, and went to Hatfield House Lane School before passing the examination for the City Grammar School.

Left: Brenda's friend Norma Nutbrown (now Kenyon) displaying the latest teenage fashion by the pool. She had called for Brenda one Sunday in May and together they had walked along Elm Lane to Longley Park. The photographs do not show much of the pool but are pleasant reminders of bygone days. Norma's parents were the caretakers of Hinde House School, which must have opened around this time. Sadly, the pool has been filled in recently.

3
SHIRE GREEN
& THE BEGINNINGS OF METHODISM

The Ordnance Survey map of 1854 shows a Wesleyan Methodist chapel near the crossroads with the Horse Shoe Inn close by. Opposite it stood Fir Croft Cottage on Common Road. At the time the 'Wesleyan' description was accurate because it was not until 1856 that this little chapel was bought by the Primitive Methodists, although the movement in Shire Green had begun much earlier. Its origin is not recorded but it is generally believed that the first Methodist preachers spread the word in houses and later barns, but no one has yet proved the location of the earliest meeting-place in Shire Green. William Ellis of Hatfield House farm always stated quite categorically that the early Methodist meetings took place in his family's historic barn. The Revd William Leary argued that it was also reasonable to conjecture that Methodist preaching locally had its origin in Thorpe Hesley during the lifetime of the Wesleys, and later in Chapeltown or Ecclesfield, for Methodist societies had been established in both these places by the start of the nineteenth century.

On Wincobank Lane in Grimesthorpe Methodist services in front of largish crowds had begun as early as 1790, first in the open air and then in a house called Hillside. A little Wesleyan Methodist Sunday School was built in 1820, followed by the chapel in 1833, but none of their members seemed to get involved with Shire Green on the other side of Wincobank Hill. It is not until 1837 that the growth of Methodism in Shire Green can be more accurately traced.

The original Chapel Deed began:

> This Indenture made the 27th day of December 1837 between the Duke of Norfolk and Francis Colley currier and leather cutter . . . land containing 294 square yards . . . being part of a field called Dog Field belonging then to Aaron Ashton as tenant bounded on the easterly side by leasehold premises of George Dawson on the westerly side by ground in the occupation of Isaac Platts on the northerly side by a certain road and highway leading from Southey to Wincobank . . .

This document leased to Francis Colley a piece of ground for 99 years. The ground was rented for the purpose of building a chapel but in 1838, when Colley assigned it to the Wesleyan Methodists, there is evidence that a chapel had in fact already been built. It seems that Colley was instrumental in building the first chapel in Shire Green but we don't know how much it cost nor who paid for it. What is certain is that by August 1838, when Colley assigned the land to a Wesleyan Methodist Trust, there is a reference to 'all that chapel recently erected'.

The chapel stood on the piece of ground occupied by the present primary school room. Despite its limited capacity, it served the Methodist congregation for forty-five years up to 1882–3 and the building of a new church.

The names of the first Wesleyan Methodist Trust members were: John Bradney, ironmonger, James Bromley, cordwainer, William Cockayne, linen draper, Benjamin Denton, grocer, Joshua Eyre, grocer, William Foster, woollen draper, John Jones, mercer, William Staley, merchant, William Saxton, stationer, Abraham Sharman, draper and grocer, Thomas Newton, ironmaster, John Chambers, ironmaster and Thomas Chambers, grocer. The Wesleyan Minister was the Revd George Marsden, whose name also appeared on the Chapel Deed.

The names of Newton and Chambers are interesting for these men were the managing directors of the Thorncliffe firm of Newton Chambers at Chapeltown, founded in 1794 and famous later for the manufacture of Izal products. John and Thomas Chambers were both grandsons of the original founder of the firm Thomas Chambers, and both men died in 1869. Thomas Newton was the son of George Newton, the co-founder of the firm. Thomas Newton, who died in 1868, was a devout Methodist all his life and was instrumental in the building of the Mount Pleasant Chapel at Chapeltown, where he was also the Sunday School Superintendent for many years. At the Thorncliffe factory morning work always began with prayers so it was little wonder, perhaps, that these men were prepared to help establish a little Wesleyan Methodist chapel (called either 'Mount Pleasant' or 'Ebenezer') in rural Shire Green.

Sadly, the evidence for the history of this Wesleyan chapel between the years 1838 and 1851 is scanty. Because of the changes that happened in 1856, it is hardly surprising that there are no record books nor any reliable information extant concerning these early years. However, on 8 April 1851 Francis Colley and the Wesleyan Trustees agreed to assign the property for the remainder of its lease to one Isaac Platts, who paid £80 for it. The reason for this unusual transaction is again not known, nor is it clear whether or not the Wesleyan Methodists continued to use the chapel for the next few years. Certainly in Methodism at this time there was a groundswell of anxious opinion about the way the Methodist church had been developing lately, and this reflected many of John Wesley's earlier concerns about the established Church of England.

The Wesleyan Methodists were being harangued at Conference for becoming too complacent and middle class and for forgetting the evangelistic message of the Wesley brothers, yet the itinerant preachers of the New Methodist Connexion were being criticised for their promotion of outdoor meetings. Wealth and social acceptability began to create further problems which fostered the growth of 'independent' Methodists, especially among the poorer working classes. After 1811, following the success of the open-air camp meeting at Mow Cop in Cheshire and expulsions from the Connexion, the Primitive Methodist Society came into being on 18 February 1812. Among the rural community of farmers and metal workers in Shire Green the new Primitive form of Methodism had a greater appeal, and it also demonstrated a greater social conscience for those less able to cope with life's vicissitudes.

For five years from 1851 Isaac Platts was the legal owner of the chapel site but on 4 June 1856 he sold the chapel to a number of new Trustees for the sum of £90. From then onwards it became known as a Primitive Methodist Chapel and the members now had their own proper place of worship.

The real reasons why the Wesleyans abandoned the place can only be guessed at but it was not a new procedure on their part to sell redundant property to other Methodists, especially if their own attendances were falling. A similar decline in Wesleyan Methodist membership took place about the same time in the village of Dore on the southern outskirts of Sheffield. However, for more than 150 years since the chapel was built on Hatfield House Lane, there has been an unbroken record of worship, first in the little old chapel and later in the new.

A modern view southwards down 'Sheffield Lane', now Barnsley Road, towards the Brushes. The high stone wall on the left supported the cutting which allowed vehicles an easier ride up the incline. The tram poles and lights are still present, although the trams departed in April 1960. This area was a vantage point for spectators turning out for the STAR Walk, a unique annual walking race of about 11½ miles around Sheffield, between 1922 and 2002, except for the war years. The old Dutch barn on Grainger's farm used to tower over the high wall on the right-hand side of the cutting.

Below: The revamped Pheasant Inn in Sheffield Lane Top, with a view along rural Hatfield House Lane towards the houses on Bellhouse Road in the distance.

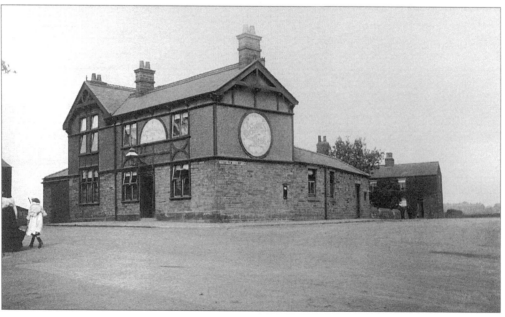

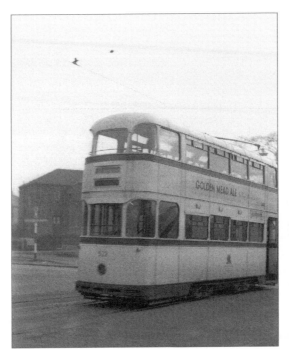

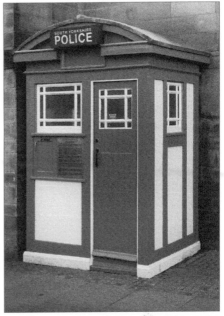

The old signpost at Four-lane-ends at Sheffield Lane Top pre-dates no. 522, one of the last trams to provide a service to this destination. Alongside the tramcar is a bench marking the site of the former police box.

The type of old-fashioned police box which used to stand at Sheffield Lane Top.

The old cottages and cornmill that used to stand at the back of the Pheasant Inn.

Will Mather's drawings appeared occasionally in the local paper. These were done in December 1972 and show, tucked in among the Brown Bayley houses on Hatfield House Lane, a curious half-timbered building that was thought to be the original Hatfield House, built in 1470, according to a deed in the possession of Norman Chaloner. The owner, a retired steel turner aged 69, was brought up here, and lived here with his wife Winifred. His family owned the property for over 200 years. The little building on the left was used by Norman's father as a small stamping shop for carver forks. Norman moved all the old machinery to the Abbeydale Industrial Hamlet where it was put on display.

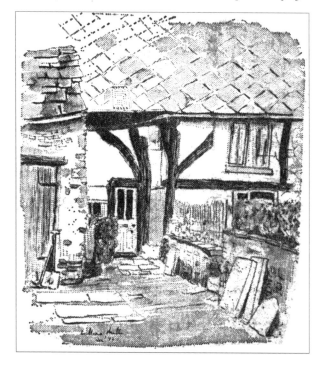

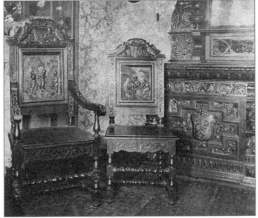

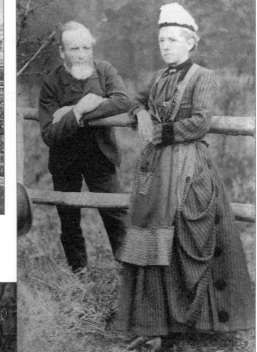

Above: *Ben Chaloner (1832–1918) lived at Hatfield House with his second wife, the former Miss Sayles.*

Above, left: *Examples of the furniture that used to grace the Chaloner's wing of Hatfield Farm House until, according to Hedley Chaloner, the family fell on hard times.*

Hedley Chaloner demonstrating fork-making in his old workshop in 1965. This scene provided the inspiration for one of the stained-glass windows in the Methodist Church at Shire Green. All the outbuildings have now been demolished, the site has been redeveloped for housing and renamed Hatfield Croft.

A painting of Hatfield House Farm – the Greaves' farm – with Chaloner's house on the left and the extreme edge of the Ellises' barn on the right, c. 1925.

To the right of the Greaves's farm buildings there used to be the oldest part of this complex, a cruck barn and farmhouse built about 1100 (although some have put it as early as AD 840). This was owned by the Ellis family until demolished in the 1950s. William Ellis re-roofed the ancient cruck barn behind the four lock-up shops which he had built at the front of his yard when he lost his fields to the new housing development.

The Ellis family was quite large. William's sister Catherine (Kate) married Walter Hazell. Their son Donald became the organist at Shire Green.

Another sister Mary (Polly) married John Ernest Ellis, who worked for the Sheffield Smelting Company but was probably better known for having played cricket for Shire Green, Yorkshire and Sussex. They had three sons, Philip, Ewart and James.

Crapper House was located down a narrow lane which became Molineaux Road (but the derivation of this name is still impossible to fathom). The house was also called 'Great Aunt Mary (Ellis)'s dower house' locally. It was demolished in 1928/9 to make way for the new Shire Green housing development.

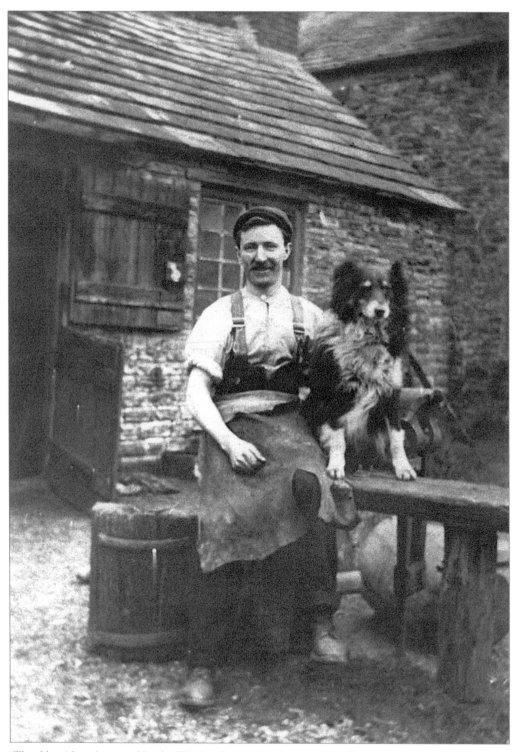

The old smithy, also owned by the Ellis family, stood to the west of the Lathe Cottages until the construction of the new Sicey Avenue decided its fate. Here Arthur Hastings is seen pausing from his labours. His dog is perched on the wooden work bench beside him.

Mrs 'Billy' Francis at the ungated entrance to the old re-roofed Lathe Cottages. They were originally roofed in locally quarried stone slabs. Mrs Francis lived in the corner cottage, the fourth door from the left.

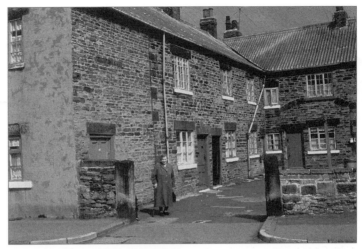

Hatfield House Lane from the junction with Sicey Avenue, looking past the cricket ground on the left towards Bellhouse Road.

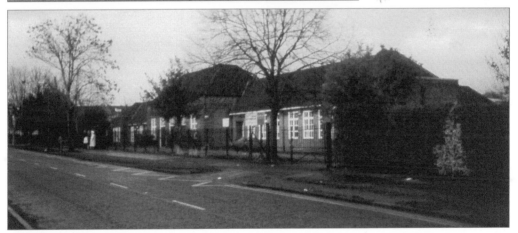

Hatfield House Lane First School showing the two wings of three classrooms each, separated by the assembly hall in the middle. The infant playground was behind the near wing, and the juniors' yard behind the far wing. The school opened on 6 February 1933 when 449 children were admitted. The school was officially opened a few weeks later by the Lord Mayor of Sheffield, Mr Ernest Wilson, on 23 March. I started at this school in Miss Butterworth's class in October 1938 and sat near Margaret Brown, Terry White and Donald Taylor. I was mortified to have to use a coloured crayon to learn to write with when I had been using a lead pencil at home for ages. Margaret soon moved up to a higher class.

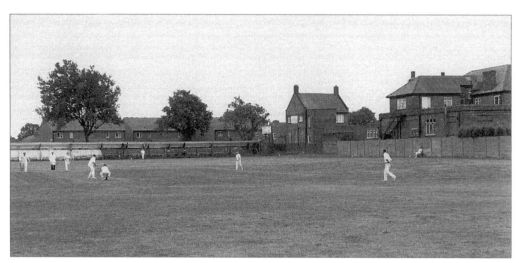

The view from inside Shire Green Cricket Club's ground looking towards Hatfield House Lane's council houses, the former Trustee Savings Bank (now a shop), and the rear of the Sicey Hotel (currently boarded up).

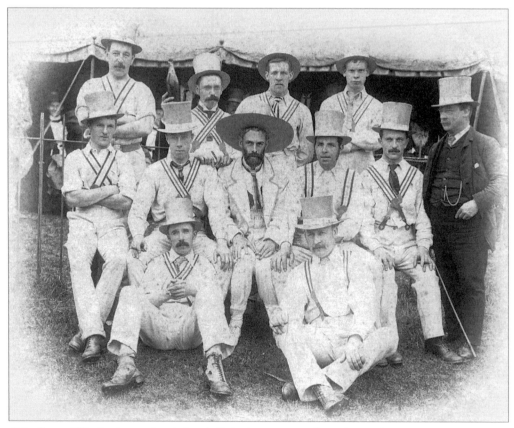

John Ernest Ellis (back row, fourth from left) in the company of top-class cricketers dressed in the fashionable kit of the time. The match was played in 1884 at Shaw Lane, Barnsley, between Pitsmoor CC and Shire Green CC. It is thought that Wake-Smith – Sheffield's Borough Solicitor – is in the centre, wearing the wide-brimmed hat, and the Earl Fitzwilliam is at the extreme right.

4

THE OLD CHAPEL

The new chapel at the heart of the village soon became the centre of nonconformist worship and fellowship which the Established Church in Ecclesfield could not match, despite the efforts of its gifted vicars and curates, such as James Dixon (until 1823) and William Ryder (until 1825), who rebuilt the vicarage in this short time. William's younger brother Thomas succeeded him until 1839, when the remarkable Alfred Gatty became vicar. So widely respected was Alfred that after twenty-one years of service his parishioners gave him £120 to enable him to take his degree of Doctor of Divinity at Oxford University. In the following year, 1861, he was made sub-dean of York on account of 'the benefits he had conferred upon the vicarage, his successful literary efforts and his standing in the diocese'.

The new Methodist chapel attracted people from all around to listen to the preachers and take an active part in the worship. They had good hymns and tunes and could certainly sing well! The male voices of the South Yorkshire coal-fields could vie with the best male-voice choirs of South Wales.

The members of the first Primitive Methodist Trust established on 4 June 1856 were: John Leach, plate-layer; John Dawson, fork maker; William Turner, carving fork grinder; Thomas Stephenson, pointsman (of Wincobank); James Haigh, coal agent; Thomas Glover, railway inspector (of Worsboro' Bridge); Charles Ramsden, coal miner (of Brightside); James Swinnerton, silver chaser; George Marsden, fork maker; Charles Raynes, merchant; Ambrose Wallis, whitesmith; and William Llewellyn, toy forger. Most were resident in Shire Green, although one or two lived in Sheffield, and a few elsewhere as indicated. The name of Charles Ramsden, the coal miner from Brightside, is marked on the deed by a cross, evidence of his inability to write his own name. It is also noteworthy that none of the original Wesleyan Methodist Trustees formed part of the new Trust.

The 1837 chapel was a small stone single-storey building; almost square, it had a centrally placed door facing Hatfield House Lane. The original stone-flagged pathway to this doorway has been covered over by a tarmacked area between the old iron gate in the stone wall fronting the pavement and the schoolroom building. This gate must be at least 150 years old. Inside the little chapel stepped-up pews/benches on the left of the doorway faced a corner pulpit to the right. Some old members remember a low platform to the right of the entrance. In the nearside corner the coal was housed and the stove heater stood just by the doorway. The chapel also had three windows above the light blue wooden panelled wall opposite the entrance. There was no musical instrument for leading the singing in those early days. Tunes were pitched by members of the choir who had learned them from the Ecclesfield singers while at work. Ecclesfield still has a fine reputation for singing old carols 'a cappella' in the local Black Bull public house at Christmas time.

A song for the time when the sweet bells chime,
Calling the rich and poor to pray
On that joyful morn when Christ was born,
On this Holy Christmas day.

The Squire came forth from his rich old Hall
And peasants by twos and threes.
The woodman let his hatchet fall
And the shepherd left his sheep.

Through the churchyard snow in a Godly row
They came both old and young.
And with one consent in prayer they bent,
And with one consent they sang.

We'll cherish it now in the time of strife
As a Holy and peaceful thing;
For it tells of His love coming down from above
And the peace it deigns to bring.

In those good old days of prayer and praise,
'Twas a season of right good will,
For they kept His Birthday Holy then
And we'll keep it Holy still.

A small pedal harmonium was later installed in the Shire Green chapel, but after a dispute it was apparently thrown into a well. Years later the harmonium was replaced by an upright piano.

The first generation of men and women in the congregation are for the most part lost to us, but not completely, for there is a record book covering the years 1856 to 1870. From this we can gather a few interesting details. This book itself is both Minute Book and Cashbook in one and it cost 3*d*, which is the first item on the debit side dated 7 July. The first audit was duly signed on 26 February 1857 by John Brownson, 'Super[intendent] preacher'. The first page of income and expenditure is shown opposite.

Lighting – even with candles – was the most costly item in those days, and cleaning was by far the cheapest, for in this half-year the cost of soap and soda was no more than 4*d*. In the second year of this ledger Mr William Turner signed as treasurer; undoubtedly he had held the post in the previous year and possibly for some time. His second yearly income was wholly derived from seat rents and an anniversary collection on 10 May amounting to £1 10*s* 1*d*. The total amount raised was the modest sum of £7 11*s* 1*d*. The book also reveals other items of expenditure that were no doubt burdensome to those early Methodists. For instance, in 1859 the little chapel was painted and cleaned. There were bills for paint and mason's work and whitewash; they also paid for a new doormat and for the gate to be repaired, in addition to items under the name of a contractor. All this was done – and the inevitable candles and soap purchased – for less than £37 for the year. But seat rents did not pay the bill.

1856	Receipts £.	s.	d.	1856	Payments £.	s.	d.
June 29	Seat Rents 12	6		July 7	Cash Book	3	
Sept. 15	Seat Rents 18	6		July 12	Brush & handle	2	0
Dec. 15	Seat Rents 13	6		"	Hymn Book	2	6
"	G. Walker for Seat Rent				6 Sept. 15 I. Platts for Candles		
1	0						
		2	4	0	"	Soap and soda for cleaning	
2½							
				Sept. 27	Candles (1lb.)		10
				Oct. 13	do = (*ditto*) (1lb.)		10
				Oct. 15	do (lb.)	10	
				Oct. 18	Coals 4	4½	
				"	Leading 3	0	
				"	Soap for cleaning	1½	
				Oct. 30	2lb. Candles @ 10d.	1	8
				Nov. 12	Chapel Rent 4	8	
				Dec. 4	Candles 2lb. @ 10d.	1	8
Dec. 31	School Rent 1	0		0 Dec. 24	Candles (1lb.)		
11							
				"	Fire shovel	3	
				1857			
				Jan. 10	Candles (2lb.)	1	10
				Feb. 21	Candles (1lb.)		8½
				Feb. 23	do (1lb.)		10
					1	9	6
					Cash in hand 1	15	6
1857							
Feb. 26	3	5	0		3	5	0

Eight pennyworth of collection books were bought and twelve members brought in varied sums ranging from 7s 6d to £1, and one member the remarkable figure of £4 5s.

As an indication of the good relations with other struggling and enterprising causes, there is the entry of £1 given to Grenoside chapel. That would have been a valuable contribution to the newly erected chapel across the valley which had cost £150. Panes of glass and items for window mending appear at frequent intervals, and one entry reports that a 'brass nob' and key were purchased for 2s 6d. The first notice of paraffin oil being bought was dated 31 December 1866; henceforth the lighting bill consisted of paraffin costs and not candles. The first lamps were installed at this time and five were hung at the cost of £2 16s, excluding pulleys and chains. There was an annual 'cleaning and lighting collection' which contributed varying amounts up to 10 shillings a year. The first debit was noted in 1868 when 15s 7d was entered as due to the treasurer for that year. This little mine of information terminates at the year 1870 and twenty years pass without trace of another cashbook.

The oldest Minute Book dated back to 26 February 1857, the date of the meeting

at which John Brownson signed the audit of the account for the previous half-year. This first Minute Book formed part of the cashbook referred to above and contained brief minutes of trust affairs until 1870. The entries are numbered and usually brief. Here are the first few:

1. That the Treasurer's accounts be approved and signed.
2. That William Turner be Treasurer for the ensuing year.
3. That John Leach be Secretary to the Chapel.
4. That John Leach and William Turner be sent letters.
5. That William Turner be Chapel Keeper for 21s per year and that the school be requested to render aid towards it.
6. That the Sunday School pay 10s for coal and towards the chapel keeper.
7. That there be two collections for lighting and cleaning on 29 March.
8. That Mrs Close be requested to preach anniversary sermons next plan.

An interesting minute of the yearly meeting for 1861 noted the appointment of an official 'to see to the alteration of the name over the door'. Did this mean that the old Wesleyan name was still inscribed? It has been suggested that the chapel was once called 'Ebenezer', rather than 'Mount Pleasant'. If so, it is more likely that this was the alteration requested, for the Primitive Methodists used 'Ebenezer' for many churches but it is seldom found to be the name of a Wesleyan chapel. However, neither the pre-1856 inscription nor the one carried out in 1861 are known for certain.

The remainder of this first Minute Book makes somewhat monotonous reading although it throws some light on the office holders and the earnestness with which they carried out their duties. This Cash and Minute Book was in good condition and among the most valuable possessions present in the chapel safe before it was stolen.

The second item of interest was a series of old class books. The oldest was dated to the year 1876 and contained twenty-seven names, together with their weekly class contribution of 1d with 1s 1d quarterage entered in the last column. The names are: R. Machin; T. Knight; T. Rose; A. Rose; Arthur Wright; Mary Wilson; G. Beardshaw; G. Mossforth; Thomas Noble; Frank Bogs; John Bogs; Ann Hodgson; Joseph Wardle; A. Hemmingfield; William Pinder; ? Wilson; Maria Noble; Jane Bramall; G. Hemmingfield; May Hulley; Daniel Wragg; Mary Wragg; Ann Eyre; Arthur Philips; John Oxspring and William Mayers.

It is interesting to note that none of the 1856 Trustees remained on this list, not even William Turner and John Leach, who were Trust Secretary and Treasurer respectively at least up to 1870. When these men passed away is not known, but by the year 1899 all but two of the 1856 Trustees had died.

In 1877 the membership was 25; in early 1878 it was 21, but rose to 31 before the end of the year. By 1880 the number had increased to 33, and to 34 in 1881. Numbers were reduced to 25 by the end of 1882, and there the first two class books ended. It is reasonable to conjecture that in 1883, the year of the building of the large church, there were not many more than 25 paid-up members of the society.

From references in the old Minute Book it is evident that there was a Sunday

School, but nothing is known of its strength nor of its teachers. One can usefully surmise that they came from among the families of the Chaloners, Ellises, Helliwells, Hemmingfields, Knights, Wrights and Wraggs among others. It is doubtful if there were any weekday activities beyond a class meeting which, according to the class book, met on Wednesdays.

From the year 1856, when the Shire Green chapel became Primitive Methodist, it appeared on the plan of the Bethel circuit. At that time there was only one such circuit in Sheffield. In March the following year the Sheffield Primitive Methodist circuit was divided into two districts or circuits. The new circuit's journal recorded that:

> The natural boundaries of the 1st and 2nd Circuits be formed by the Manchester, Sheffield & Lincolnshire Railway (later known as the Great Central Railway) northwards and all places to the north-east side of the railway shall belong to the 2nd Circuit and all places to the south-west of the railway shall belong to the 1st Circuit.
>
> Signed: John Brownson, President
> Joseph Wilfred Howell, Secretary

So the Bethel circuit was divided, and the new Stanley Street circuit was formed. It consisted of nineteen societies: Bethesda on Stanley Street; Burncross; Rawmarsh; Thorpe Hesley; Shire Green; Pitsmoor; Brightside; Rotherham; Wickersley; Elsecar; Bradgate; Greasboro'; Whiston; Laughton; Kilnhurst; Attercliffe; Brinsworth; New York and Carr. At this time only eight were located on the Sheffield side of the circuit, and of them only three had chapels. Shire Green was one of them. In 1859 the 2nd circuit was divided again at the quarterly meeting but Shire Green remained with six other societies in the Stanley Street Circuit until about 1900, when Shire Green and Meadow Hall at Low Wincobank formed a new circuit known as the 10th. The new Petre Street circuit was formed in 1872, and in 1908 it was united with the 10th circuit, thus bringing Shire Green into the Petre Street or 3rd circuit, as it became known, in which circuit it remained until Methodist Union in 1932 and the formation in 1934 of the Sheffield North East Circuit.

Up to 1831 the greater part of the population of Sheffield was supplied with water from wells and other private sources like the 'Water Carrier' who daily sold his customers a pailful or two of water for a penny. By Acts of Parliament reservoirs of water such as at Redmires were authorised and building work went on apace in various river valleys. However tragedy struck when the new Dale Dike Reservoir in the Loxley Valley gave way in 1864, loosing 700,000 million gallons of water down the valley and causing the Sheffield Flood disaster with the loss of 244 lives.

From 1880 much housing development had begun to take place to the south of Shire Green on the former Page Hall estate. The new Firth Park was opened in 1875 by the Prince and Princess

Medallion given to commemorate the opening of Firth Park in 1875.
There was also a smaller bronze medallion.

of Wales, and a string of quality houses were built facing the park along the newly created Firth Park Road. This development culminated in the construction of a large United Methodist Church in 1911 in the fields at the foot of Bellhouse Road by the Troughs. More houses, many destined to convert their parlours into small shops, began to creep up both sides of Bellhouse Road towards Pear Tree Lane and Watkins farm on the west and Windmill Lane on the east, and a large new public house and dance hall, the Wharncliffe Arms, was built on Bevercotes Road to serve this new estate.

At the turn of the century much local interest had been focused on the fortunes of the town's two Association Football clubs, the 'Wednesday' and the 'United' – 'The Owls' and 'The Blades' which had each twice won the FA Challenge Cup and lost a Final between 1890 and 1907.

THE CHAPEL & ITS PERSONALITIES

*A map dating from 1854 showing the little
Wesleyan chapel south of Hatfield House Lane.*

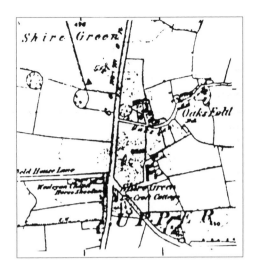

Below: *A later map showing the site as a Methodist
chapel with the description Primitive in parentheses.*

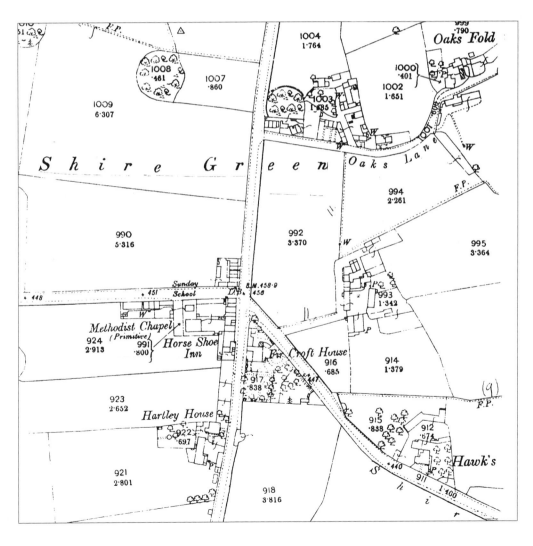

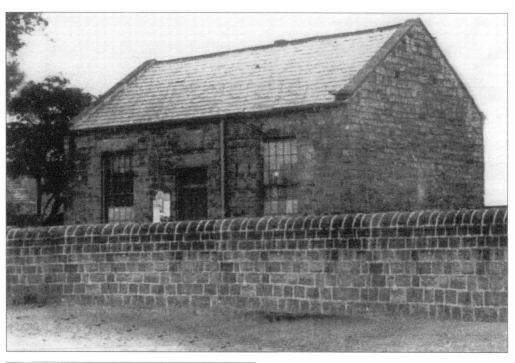

Above: *The original Shire Green chapel as it would have appeared in 1837.*

SHIREGREEN

PRIMITIVE METHODIST

SUNDAY SCHOOL.

THE ANNIVERSARY SERVICES

Of the above Sunday School, will be held

On SUNDAY, MAY 30th, 1886,

When Sermons will be preached in the Afternoon

at 2-30, by

MR. LLEWELLYN,

And in the Evening at 6 o'Clock, by

MR. J. BARKBY.

The Services will be continued on Monday Evening,

WHEN A

PUBLIC MEETING

Will be held, when Addresses will be given by the

Rev. G. LEE; Mr. J. GRAVES,

AND OTHER FRIENDS.

Chair to be taken at 7-30, by Mr. C. BROWN.

A choice Selection of Hymns and Anthems will be given
at each Service by the Scholars, assisted by
Teachers and Friends.

Collection at the close of each Service in aid of the Sunday School.

The 1886 programme for the Sunday School Anniversary, held in the new church which had been built just three years earlier.

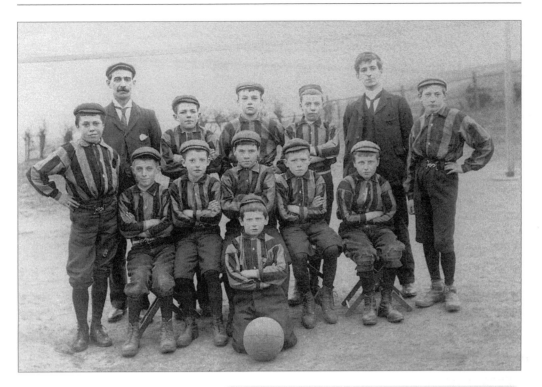

The Sheffield Lane Juniors' team
that played in the All Saints' Boys'
Football League, 1902/3.
Back row, left to right: Mr Foulstone;
A. Clayton; W. Thompson;
B. Bolton; Mr G.H. Butterworth.
Middle row: N. Martin;
G. Hemmingfield; F. Thompson;
G. Gregory; H. Hemmingfield;
W. Riley; S. Oxspring. Front row:
S. Webster.

The Primitive Methodist Centenary
letter heading for the celebrations in
1907–10.

Phillip Ellis, aged 23. The eldest son of Polly and John Ernest Ellis, he was called up on 16 April 1917 into the King's Own Yorkshire Light Infantry. Sent to Flanders, he was wounded and died later in 1917 in the Bandaghem Clearing Station. He is buried at the Haringhe Military Cemetery there. Had he been three months older, he would have been exempted, he said in a letter to his cousin Bert Maycock. His girlfriend Gladys Hett said her sister Hilda had heard from Walter Bell that the 'Front was a bit rough and he had to scrape the mud out of his sleeping place and spread down straw before he could lie down'.

Haringhe Military Cemetery, Belgium.

Laura Ellis never married. She taught first at Shire Green National School and later became headmistress at Malin Bridge – and dedicated female teachers didn't get married. A devoted member of the Shire Green Church, she was a very well-educated, much travelled and gifted young lady who attended Sheffield's Firth College, later the University, winning summos honores *the Latin Prize there in 1893.*

Below: *Laura's letter of February 1918 to her nephew Bert Maycock, who was convalescing in hospital after being wounded in the leg while serving abroad with the Royal Leicesters, mentions only briefly her own illness, but sadly she died just a few weeks later.*

Above: *Another of the Ellis's daughters, this is Emily Maycock with her youngest daughter Gwendoline and the younger son of the squire of Woolley House, Colin K. Hawkins, in the field near the cricket ground in the late 1920s. The Plumps and Bellhouse Road houses can be seen in the background.*

Shiregreen P.M. Church.

OPENING OF
New
Memorial Organ

Saturday, October 27th, 1928,

at 3 p.m.

Order of Service.

Hymn 827. "Jesus shall reign"
Prayer Rev. D V GODFREY
Introduction of O C WILSON Esq J.P.
 by Rev. E GOLDTHORPE
Chairman's Address
Scripture Reading Rev. W E ROBSON
Presentation of Key by Mrs L OVERLAND to Mrs E
 BAKER who will declare the Organ open.
 (Congregation standing)
Dedicatory Prayer ... Rev. E GOLDTHORPE
Hymn 772. "All people that on earth do dwell" ...
Solo "Thanks be to God" Miss RHENA WRIGHT
Dedicatory Address ... Rev E GOLDTHORPE
Announcements and Offertory
Solo "A Hero's Requiem" Miss DORIS MAYCOCK
Votes of Thanks ... Rev. J .A McGAIN
Hymn 608. "For all Thy Saints"
Prayer

W. Dobson, Printer, Firth Park, Sheffield.

The programme for the dedication of the New Memorial Organ in 1928, in tribute to the members of the church and district who had served in the First World War.

Above: *The style of wedding photographs changes with each generation. This one of James Leslie Ellis and Marion Ridgeway in December 1930 is typical of the period. Marion's friends (and Jim's cousins) Marjorie and Joan Pickard and a small bridesmaid pose with the bride. Behind Joan stands the best man, Colin K. Hawkins.*

James and Marion's only daughter Esme showed an early talent as an artist and became a sculptress and writer. Her first book, Pathway to Sunrise, *contains many allusions to Shire Green and Sheffield. Her initials are to be found on a tile placed with others on the inside wall of the 1938 Sunday School building.*

THE METHODIST CHURCH,

NORTH EAST CIRCUIT,

SHEFFIELD.

THE

FOUNDATION STONE-LAYING

CEREMONY

OF THE

New Methodist Sunday School

AT

SHIREGREEN

ON

Saturday, April 9th, 1938,

at 4 p.m.

The official programme for the 1938 stone-laying ceremony for the new Sunday School building which would incorporate the 1837 chapel.

Below: *Clifford Bilson married Joan Pickard in December 1938, just before he joined up. Also present are Clifford's older brother Ernest; their mother Mrs Bilson; Joan's father Alfred Pickard; Joan's mother Edith (née Ellis) and Clifford's younger brother Harry. Seated are Clifford's sister May (left) and Joan's sister Marjorie.*

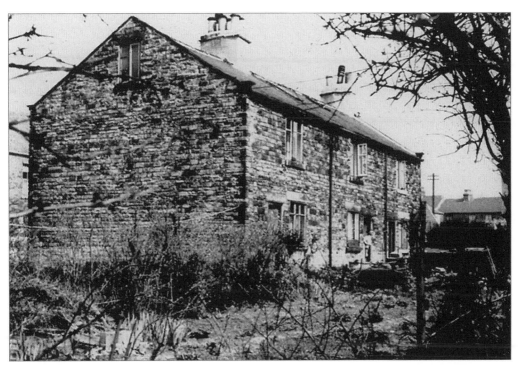

Three cottages stood almost adjacent to the chapel before Winkley Terrace was created. Miss Clara Nelson occupied the centre dwelling and can be seen here standing in the doorway of her cottage. She baked bread and teacakes to earn a little extra money and at one time sold comics like the Dandy *and* Beano. *Doris Maycock had a weekly standing order for four teacakes which I used to collect for her on Saturday mornings. The kitchen always smelt warm and wonderful.*

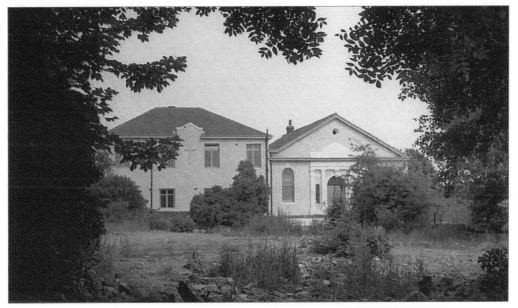

When the cottages were pulled down (because they didn't possess a second outside doorway), the view of the chapel and Sunday School from Verdant Way temporarily recreated across the former well-tended gardens this rural aspect of old Shire Green.

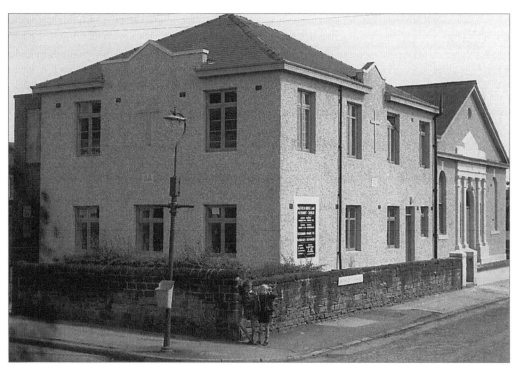

The street lamp on the corner still occupies the same position as the former gas lamp of over 100 years ago. The stone wall and iron gate date back even further, but the wall in front of the large church has been lowered for the benefit of photographers at weddings and so on.

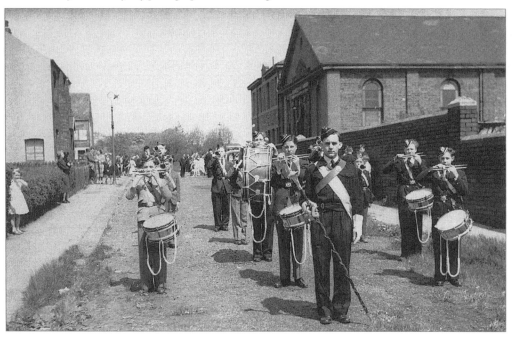

In the cul-de-sac of Winkley Terrace, the 37th Company of the Boys' Brigade, led by mace-bearer Peter Marriott, has just returned from its Whitsuntide Parade. The boys are preparing to play the General Salute before being dismissed.

Shire Green Church football team, c. 1950. They played in the Bible Class League. Back row, left to right: Bernard Scrivener, Harold Roden, Tom Clark, -?-, Neville Smith, Doug Gould. Front row: Brian Sumner, Eric Cox, Cyril Brown, Derek Furniss, Jack Clark.

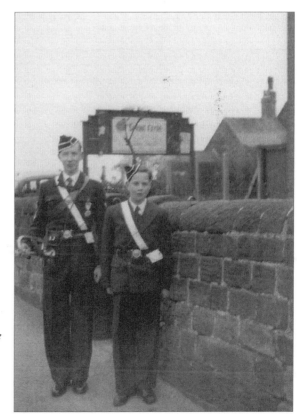

Bryan and Keith Woodriff standing in front of the ancient wall. The old chapel garden is behind the fencing, with the rear of the old shop and house by the Horse Shoe Inn. During the Second World War the space in front of the garden, once occupied by old workshops, became the site of an Emergency Water Supply tank and a large brick-built air raid shelter.

Above: *The chapel garden after restoration, revealing the hawthorn hedge and the loss of the buildings next to the pub although a little of the boundary stone wall still remained, formerly part of a workshop or outside privy. Across Bellhouse Road can be seen the last of the large elm trees that used to line the road.*

Mr Marriott, Doris Maycock, Joseph Woodriff, Mrs Marriott and Louis Overland temporarily hinder the traffic flow after their return from a windy Whitsuntide but they allowed the no. 2 Outer Circular Bus to pass in front of Clara Nelson's cottage before the picture was taken.

Above: *Janet Chaloner as the Angel Gabriel in the Sunday School nativity play in about 1949. Stephanie Bucklow and Barbara Jackson are the small angels on either side. Barbara attended Velma Furniss's dancing school, and was a member of the Band of Hope and the Sunday School.*

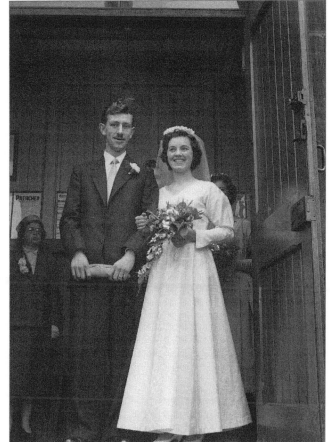

David Budd and his bride Jean (née Smith), posing in the old entrance to the church in 1959. This picture reveals the ancient cramped appearance of the church before the alterations were made.

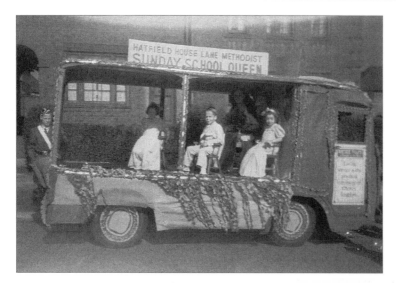

An electric Co-op milk-float provided the carriage for the parade for the Sunday School Queen and her retinue in 1950: (left to right) Roma Cooper; Richard Brown; Kathleen Peace and Queen Janet Chaloner. Billy Sharpe in Boys' Brigade uniform looks on.

Members of the Boys' Brigade and the Girls' Life Brigade precede the Sunday School Queen's float.

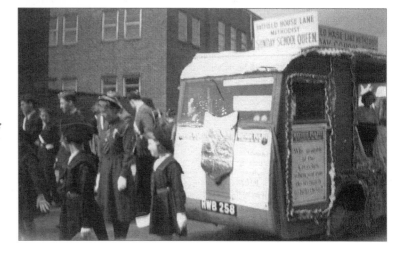

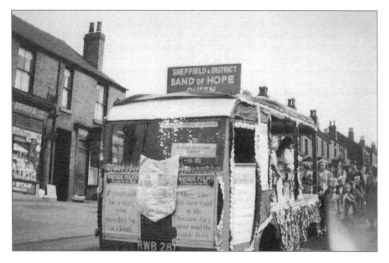

The Band of Hope Queen's float in Bellhouse Road, Nethershire, during the 1950 parade.

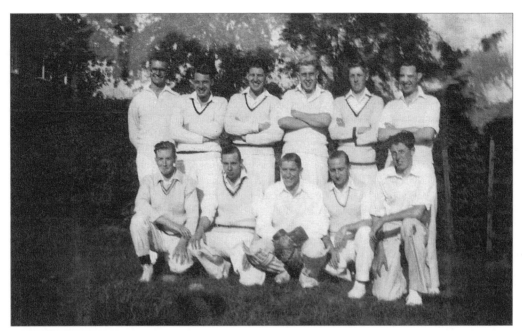

The Hatfield House Lane Sunday School cricket team in the early 1950s. Back row, left to right: Peter Mitchell; Geoffrey Smith; Cyril Brown; Derek Cadman; Brian Sumner; Michael Sinclair. Front row: Bryan Woodriff; Derek Furniss; Ron Brookes; Bernard Scrivener; Les Newsham. Clifford Bilson was twelfth man. On this occasion the team had travelled to Dronfield to play the match. It was a long hard walk to the ground up the hill from the station.

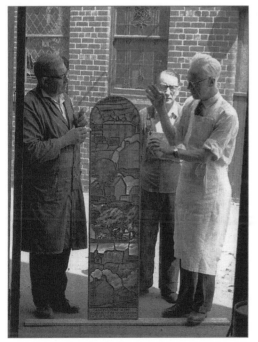

At Finch's workshop in Abbeydale, the craftsmen show the first completed stained-glass window depicting aspects of farming in Shire Green.

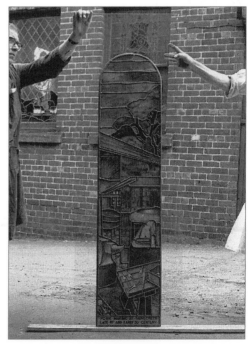

The other window depicts the craft of fork-making in Shire Green, based on Hedley Chaloner's forge.

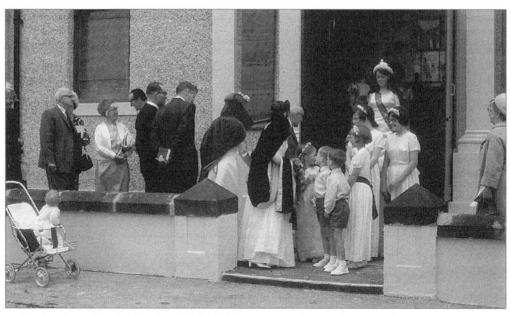

Following the service of dedication in July 1969, the two windows are ready for the unveiling. Left to right: Mr Clifford Wragg, Miss M. Hemmingfield talking to Mr G.K. Sugden, the President of the UK Cutlery and Silverware Manufacturers' Association, who unveiled the fork-making window; the Revd A.W. Chant, Mr C. Brown, Pauline Woods, the Sunday School Queen, Mr E. Cooper, Judith Crowson, Band of Hope Queen, and Miss E.D. Maycock who unveiled the farming window. The two windows had cost £210 and were paid for from monies raised through lantern-slide talks on the local history of Shire Green and surrounding areas.

While the congregation witnessed the unveiling of the windows, Ann and Joanne were entirely wrapped up in their own conversation, totally oblivious to the ceremony going on above their heads.

Above: *When five ministers gather, it is a unique opportunity for an historic photograph which in this instance also records the recent refurbishment of the church interior. Left to right: Revd Ron Thomson of St Hilda's; Revd D.H. Jefferson; Revd Vinson; Revd ?; Revd J.A. Clayton. Pat Smith and Betty Sharpe watch approvingly while Cyril Brown sorts out the hymn books in the choir stalls.*

When duty called, Mother Christmas – aka Betty Sharpe – had the job of accepting the gifts at the Toy Service.

Playing at his beloved organ, as he did most Sundays and on special occasions, church organist Donald Hazell is seen enjoying a musical moment at the end of a wedding.

Jean and Doreen, Donald Hazell's two daughters, lived with their parents at 2 Crowland Road until they married. Their initials, with many others, are to be found on commemorative tiles on the upper Sunday School wall. Jean was the youngest person to have laid one of the 1938 foundation stones, too.

In 1952 the Drama Group presented Golden Rain. *The cast were (left to right) Peter Hird; Ruth Wragg (seated); Diane Humphries; Bernard Scrivener; Joyce Sorsby; a young Trevor Gould; Velma Furniss and Doug Gould (seated).*

A KNIGHT'S PRAYER

MY LORD, I am ready on the threshold of this new day, to go forth armed with Thy power, seeking adventure on the highroad, to right wrong, to overcome evil, to suffer wounds and endure pain if need be, but in all things to serve Thee bravely, faithfully, joyfully, that at the end of the day's labour, kneeling for Thy blessing, Thou mayest find no blot upon my shield.

The 'Knight's Prayer', which Mildred Hemmingfield requested a teacher at her girls' school in Kimberworth to produce for her, was reproduced at imperial size, framed and hung in the lower Sunday School for many years until after Mildred's death. She encouraged young people to learn the words and follow its message.

One of the church's many fund-raising activities was this mock wedding. Left to right: Mrs Wragg, Mrs Furniss, Mrs Cox, Mr Cooper (the bride), Mr Cox, Cyril Brown (the groom), Mrs Steggles, Mr Steggles, Miss Hemmingfield – the minister, and Mr and Mrs Hanson.

The Sisterhood organised regular trips to places of interest such as this one to Gretna Green, where Mrs Cox played the role of 'the runaway bride'. The coach driver was her 'husband'. Some of the 'witnesses' were Pattie Rhodes, Mrs Smith, Mrs Hemmingfield, Mrs Hanson, Edith Scrivener, Mrs Townroe, Mrs Furniss, Mrs Cox, Muriel Woodriff, Miss Hemmingfield, Alice Briggs, Gertie Hemmingfield, Mrs White and Mrs Sedgwick.

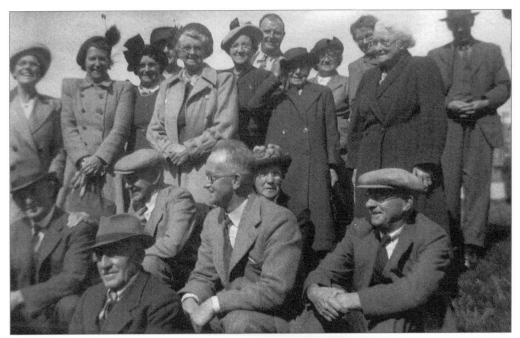

The chapel also staged outings, as on this occasion to the Yorkshire Dales. Grouped here are, left to right: -?-, Marjorie Pickard, -?-, Mr Wragg, Mrs White, Miss Rhodes, -?-, -?-, Mrs Steggles, Mrs F. Rhodes, -?-, -?-. Seated are Mr Frank Rhodes, Mrs C. Wragg and Mrs H. Chaloner.

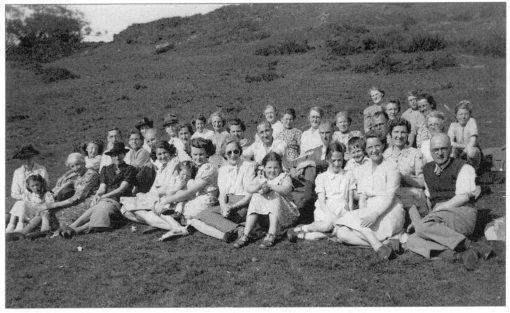

Among those taking part in the chapel Bank Holiday hike to Wyming Brook – a fabulous Sheffield beauty spot – in 1946 were Clara Nelson, Velma Furniss, Mr Furniss, Mrs Furniss, Miss Pattie Rhodes, Ernest Cooper, Edith Scrivener, Mr Mitchell, Mrs Cooper, Mrs L. Smith, Bernard Scrivener, Gertie Hemmingfield, Kath Wragg, Mrs Frank Rhodes, Mrs H. Hemmingfield, Mr Hemmingfield, Pat Smith, Mrs Townroe, Leonard Cox, Eva Brookes, Mr Cox, Mrs Cox, Mrs Wragg, Muriel Woodriff, Mrs Steggles, Clifford Wragg and Sheila Timms.

When cars became more popular, outings became more intimate, with passengers rendezvous-ing, as on this occasion, somewhere in Derbyshire in 1955. A picnic beside the highway was a pleasure in those days and not ruined by petrol fumes. Enjoying the fresh air are (left to right) Joe Woodriff; his wife Muriel; Winifred Ricketts with her husband Horace; Margaret Hall (née Swift) and Sydney Hall; Colin Hawkins; a friend; Doris Maycock and Selina Corbridge, Colin's cousin. Muriel and Winifred had become friends at the Victoria Hall Choral Society. The Ricketts had one daughter, Helen. Muriel had known the Halls for many years. They had a son Michael who attended the Redcaps school. Colin and Doris were life-long friends who never married and continued to live in separate houses. Selina was post-mistress at Barrow Road in Wincobank for many years.

5

FURTHER DEVELOPMENTS

Methodism was on the move during most of the latter part of the nineteenth century, with new hymns being written and new chapels being built at regular intervals; for example Wincobank's in 1874 and Trinity, Ecclesfield, in 1897. Thus it was not surprising that Shire Green also felt the need to expand urged on by the words of Frances Havergal's hymn of 1874, 'Take my life and let it be consecrated Lord to Thee.'

On 28 September 1883 an additional lease was obtained from the Duke of Norfolk for 785 square yards of land adjoining the existing property. Ten shillings a year had been paid for the leasehold of the smaller portion; now the amount was raised to £3 15s. The foundation stone of the new chapel was laid on 18 September 1882. On 25 February 1883 the chapel was opened, with the Revd Joseph Odell as the special preacher. He later became President of the Primitive Methodist Conference in 1900.

The surviving trustees of the 1856 Trust carried through the work of erecting the new chapel and it was not until 1899 that a new Trust was formed. In a memorandum dated 7 March 1899 it was disclosed that all but two of the members of the old Trust had died. Of these two, Ambrose Wallis had left the country and William Llewellyn had resigned. It should be pointed out, however, that in 1883, when the new chapel was opened, ten people signed the deed, none of whom had been Trustees of the old chapel, although most were members. When the new Trust was formed in 1899, nine of the ten became the newly appointed Trustees of the whole property. They were: Walter Phillips, fork grinder; David Haigh, merchant; Thomas Rose, grocer; George Gladwin, steel manager; Thomas Knight, foreman plate layer; George Hemmingfield, fork grinder; William Kemble, grocer; Matthew Wright, fork grinder and George Beardshaw, fork grinder. The document was signed by the Chairman, Matthew Browne Stamp, minister.

The first insurance policy, dated April 1884, described the chapel in some detail: 'Chapel, including pulpit or rostrum, pewing, forms, gas, lamp and candle fittings, blinds, rollers, racks, desks, tables and chairs therein.' The whole was insured for £480, with an additional £20 for the harmonium, and all this for an annual premium of 10 shillings. The new chapel seated a congregation of 260 people, while the old chapel was transformed into a Sunday school, holding 100 scholars. In 1900 the first pipe organ was installed at the cost of £125. It served the church for twenty-eight years. In 1903 the chapel was redecorated for the modest sum of £30 10s, and in the following year a new boiler was installed at the cost of £12. On 30 May 1908 the land was conveyed as freehold to the trustees for the sum of £198 14s 8d.

The names of four men connected with the chapel who lost their lives in the First World War were inscribed on a memorial plaque which was eventually affixed to the

> This organ is dedicated to the loving memory
> of the young men of this church and school who
> lost their lives in the Great War 1914 – 1918.
> 'Lest we forget'
> October 27th 1928
> Lawrence Hemmingfield Clarence Walker
> Philip Ellis Benjamin Hutchinson M.C.

new organ in 1928. It read:

A framed Roll of Honour used to hang inside the church porch until about 1970, listing the names of local people who had served in the forces. There were some from Low Wincobank as well, such as Phil Ellis's first cousin Bert Maycock, who was badly wounded in the knee. A German doctor saved his leg from being amputated. But a disillusioned Bert never unwrapped the two service medals he was sent.

On 6 June 1919 the chapel was registered for the Solemnisation of Marriages and six days later it was granted a Certificate of Worship, written and signed by the Revd Joseph Herbert Barker.

On 4 March 1922 the Trust was again renewed. Seven of the former members had died, namely Messrs Haigh, Rose, Gladwin, Wright, Knight, Kemble and Beardshaw. Walter Phillips and George Hemmingfield decided to continue. The newly appointed trustees were: John Robert Spanton, engineer; Alfred Henry Short, builder (and local preacher); Edward Hewson, gold and silver refiner; James Edward Rhodes, retired; Arthur Hemmingfield, furnaceman; Walter Allen, baker (and local preacher); Arthur Knight, estimating clerk; John Ernest Ellis, gold and silver refiner; Herbert Matthew Hemmingfield, electrician; Harry Gordon, clerk (and local preacher); and Alfred Pickard, clerk. Willie S. Barrett, as chairman of the meeting, also signed the document.

In the year 1928 electric lighting was installed in the chapel, following another projected plan to install a new organ. The organ was officially 'opened' on 27 October by Mrs E. Baker, and Mr Harold Marsden (a Fellow of the Royal College of Organists) of Rotherham gave a recital the same evening. The following day, Sunday, another recital was given by Mr Arthur Littlewood and on the following Sunday the Shire Green Harmonic Society sang Mendelssohn's oratorio *Elijah*.

The organ was built by Messrs Bower & Dunn of Sheffield and was entirely new except for the case, which had previously housed the old organ. The instrument, so Kath Rhodes remembered, was delivered by rail to Grange Lane station and brought up to Shire Green by horse and dray. It was dedicated as a permanent memorial to the men who lost their lives in the First World War.

In 1929 a new heating system was installed. Together with the electric lighting and the organ, the work cost altogether £629 9s 9d and all save £72 had been raised by the time the work was finished.

At the Methodist Union in 1932 many churches were brought together from different Methodist connexions. The new North East Circuit consisted of: Potter Hill (built in 1839); Shire Green/Hatfield House Lane (1837/56); Wortley Road

(1864); Burncross (1865); Crabtree (1865); Mount Pleasant (1866); Petre Street on Ellesmere Road (1868); Grimesthorpe Road (1870); Wincobank (1874); Warren (1876); Stoneygate (1877); Blackburn (1845/95); Trinity, Ecclesfield (1897); Dearne Street (1898); Trinity, Firvale (1899); Station Road, Chapeltown (1907); Firth Park (1911); Jenkin Road (1911); Wesley Hall (1921); Ebenezer, Ecclesfield (1926); and Beck Road, Nether Shiregreen (1936).

Some of these chapels and churches have been demolished, others closed down and some rebuilt, but many are still serving the communities for which they were built.

The Trustees at Shire Green adopted the New Model Deed in 1935. It was signed, sealed and delivered by Herbert M. Hemmingfield and Alfred Pickard, and was witnessed by the Revd James Moorhouse, minister, and Ernest Wright, Walter Allen and Arthur Knight.

The Trust was renewed once more in 1936. Eight of the 1922 Trust members had died, namely Walter Phillips; George Hemmingfield; John R. Spanton; Edward Hewson; James E. Rhodes; Arthur Hemmingfield; Herbert M. Hemmingfield and John Ernest Ellis. Harry Gordon retired from the Trust but Arthur Knight; Ernest Wright; Alfred Pickard; Alfred H. Short and Walter Allen continued to serve alongside nineteen new members, among them eight women. They were: George Henry Townrow; Walter Bell; Edgar Ellis Hemmingfield; Donald Hazell; Lewis Overland; Archibald Burgin; Colin Hawkins; James Leslie Ellis; Harold Hemmingfield; Charles Smith; George Mitchell; Elizabeth Knight; Esther Ann Knight; Martha E. Rhodes; Mildred Hemmingfield; Lizzie Wragg; Mabel Steggles; Emily Dorothea Maycock and Annie E. Talbot.

Since the end of the nineteenth century, during the ministry of the Revd Matthew Browne Stamp, there had been an awareness of the pressing need to enlarge the Sunday School premises. A fund had been started for the erection of a new building but the sum had grown only slowly and hopes of carrying out so large an extension had to be abandoned. Only £40 was raised and it was decided to hand over this sum of money to an independent trust. It was then used for the building of the first part of the Reading Room on the opposite side of Winkley Terrace from the chapel. The Reading Room was used to house Belgian refugees during the First World War and boasted a built-in bathroom with hot and cold water and flushing toilets – among the first in the area.

The question of the extension kept being voiced and after much effort some £220 was raised. In 1928–9 both the new electric organ and the new heating system had been installed and once again the fund was used to help defray expenses. In 1933 a huge effort was made in the form of a Church Golden Jubilee (1883–1933) Bazaar to help restore the £220 and secure a sound basis for the future enlargement of the Sunday School premises. The two-day bazaar was well worth the effort and by 1938 the dream of many years began to be realised. On 9 April 1938 the foundation stone of the new school was officially laid. The names of those who laid stones is not recorded officially anywhere in the building but it is a long and remarkable list: Miss Brenda Cooper; Miss Jean Hazell (aged 6); Miss Eileen Rhodes (aged 8); Miss Rita Wragg (aged 8); Miss Eveline Woodriff; Miss Winnie Moon; Miss F.S. Saul; Miss Marjorie Wilson; Mrs H. Hemmingfield; Mrs Helliwell; Mr and Mrs Challoner; Mr and Mrs Townrow; Mr and Mrs Wheatley; Mr W. Brookes; Mr John Ellis; Mr Feltrop; Mr Ron Steggles; Mr Willie Townrow; Mr Desmond Cooper (laid by Mr

Richard Knight); Alderman H.W. Jackson (on behalf of Sheffield Sunday School Union); Sheffield Sunday School Union (laid by Ald. H.W. Jackson); Petre Street Sunday School (laid by the Revd J.W. Swarbrick); Circuit Sunday School Council (laid by Mr C.B. Geach); Potter Hill Sunday School; Shiregreen Band of Hope (laid by Miss Ida Roebuck); Shiregreen Teachers' Preparation Class (B. Scrivener and R. Brookes); Social Guild (laid by Mrs Talbot); Christian Endeavour (laid by Miss E.D. Maycock); Sisterhood (laid by Mrs A. Knight); Choir (laid by Mr H. Hemmingfield); Trustees (laid by Mr Ernest Wright); Shiregreen Sunday School (laid by Miss Gwen Brookes and Mr Neville Smith, Sunday School Queen and Captain).

After the service, conducted in the chapel by the Revd G.V. Geach on 10 September 1938, the door to the new Sunday School premises was officially opened by Mrs L. Wragg of Loxley. On the back wall of the upper school room there are fifty-six commemorative tiles inscribed with the initials of the many children and young people who sold Penny Bricks from booklets to help pay for the new extension. The cost of this extension was £1,675 and on the day of the opening £500 was still needed. In the same year the chapel was redecorated but it was not until 1950 that the Shiregreen Society was clear of debt.

Since that time no major alterations have taken place, except for the erection of an industrial ventilator on the Sunday School roof. In 1954 the chapel was fitted with a hearing aid, at a cost of about £50.

The Trust was renewed again in 1954 because since 1936 six members had died, namely: Arthur Knight; Ernest Wright; Alfred Pickard; A.H. Short; Gregory Henry Townrow and Elizabeth Knight. Esther Ann Knight and Walter Bell stepped down but the remaining fifteen members chose to continue. Formidable though this team was, the additional new members made the Trust one of the strongest found in any church, and one that promised well for the future. The new members were: Brian Hemmingfield, Elizabeth White, Cyril Brown, Phyllis Smith, Joseph Woodriff, Alice Briggs, Owen Hanson, Evelyn Furniss, Michael Gordon Sinclair, Gladys Doreen Sylvester, Geoffrey Stuart Smith, William Ronald Brooks, Derek Furniss, Clifford Wragg, Bernard Scrivener, Ernest Cooper, Douglas Gould and Clifford James Bilson. The memorandum of choice and appointment was signed by the Revd Walter C.H. Fell on 9 July 1954.

Clifford Bilson, who was demobilised from the Royal Army Ordnance Corps after war service in North Africa, Egypt and Italy, and Cyril Brown of the Royal Lincolnshire Regiment, who had been taken prisoner in Italy, transferred to hospital in Germany and been repatriated in an exchange of prisoners, both joined fully in the activities of the church. Geoffrey Smith did his service, I was told, as a 'Bevin Boy' in the coal mine at Smithy Wood.

The yard behind the old cottages at the corner of Bellhouse Road, seen from the site of Mr Rose's old fork-shop on Hatfield House Lane. It was a functioning workshop when I was attending primary school. Teddy Chaloner lived in the left-hand corner house before Billy Edward Cooke came. The next house was the home of Mrs Jeffrey (Fanny) and Annie Rose, though Fred Chaloner lived there for a while. The third cottage housed Mr Turner, but also Harry Shackleton with Larry ? and his daughter. In the fourth property lived May Brown and Mrs Tingle, and finally Cyril Hobson. In the first house past the passage on the Bellhouse Road side used to live William Matthew Ellis, James Ellis's grandfather. The properties were demolished and the area grassed over in about 1975.

All change at Bucklow's corner across Bellhouse Road. The four former shops have all been returned to domestic use. They used to be, left to right, a wool and clothes shop; Ellis's/Gregory's grocer's shop; the fish and chip shop; and Mrs Bucklow's tobacconist, stationery and sweet shop where ice-cream and pop were also sold, a boon to visitors to Concord Park about 20 yards away to the right.

The last view of a working Horse Shoe Inn. The last elm tree is still standing on Bellhouse Road before road widening removed it. The roof of St Hilda's can be seen in the distance on Windmill Lane.

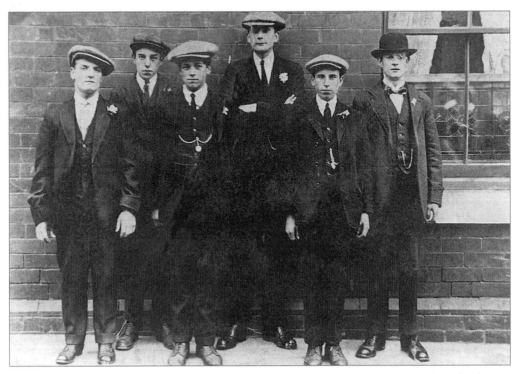

Young men outside the Horse Shoe, dressed in their best and sporting a variety of buttonholes for the occasion. 'Is one Stuart Chaloner?' asks Colin Wilson.

Hafferty's Court, the new block of flats built on the site of the old Horse Shoe was named after the pub's landlord in the 1940s and 1950s. The Methodist Church sold its garden to the developers and so another bit of old stone wall was removed as it was not in keeping with the appearance of the new development.

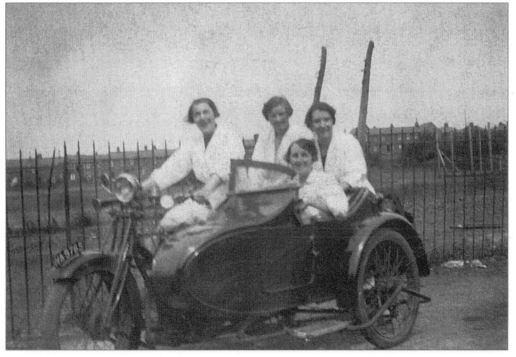

Doris Jackson, riding pillion on the motorbike, with three girlfriends from the Brightside & Carbrook Co-operative Society Bakery further down Bellhouse Road. They are pictured in Torksey Road, with the houses on Sicey Avenue in the distance.

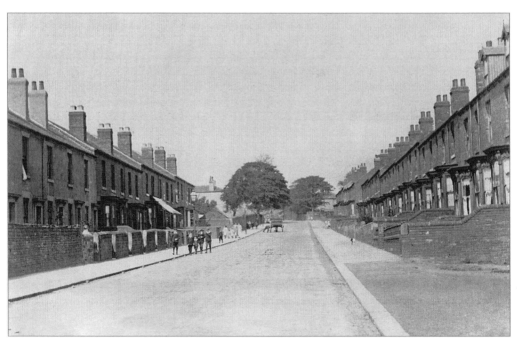

The view northwards up Bellhouse Road from Hartley Cottages, showing the row of shops and Hartley House and farm beyond on the left. On the right are the houses near the corner of Shire Green Lane, with Fir Croft House behind the elm tree in the distance.

A more casual wedding photograph, snapped on the B&C Dairy's lawn in front of the room set out for the reception. Bride and groom Ian and Carole have bridesmaid Susan Bilson (Ian's cousin) and best man Paul Smith on their right and the other bridesmaid, Carole's sister Gillian, on their left, talking with her parents, Mrs and Mr Clark. The backdrop is provided by the end wall of Hartley Cottages. In the distance on the left is the little Hatfield House Lane Church.

In one of the gardens at the rear of Hartley Cottages in 1927 is Colin Wilson's cousin Maurice Richardson, wearing the maroon school uniform of the local Firth Park Grammar School. He is with members of his family.

The B&C Dairy offices and reception rooms were demolished recently in preparation for a vast housing development. This was the site of the former Watkins' farm until it was knocked down about the time of the First World War to allow the building of the B&C stores, dairy and laundry.

A wedding group outside one of the old Pear Tree Cottages behind the National School on Bellhouse Road. Doris Jackson is in the centre of the front row holding the bouquet with the darker foliage. In the distance is Primrose Avenue.

An artist's impression of Pear Tree Lane in 1931 showing the approach from Bellhouse Road towards the fork-shops, School House and the back of the National School.

Some time after the closure of the National School, a freezer centre owned by J. Oldfield & Sons was built on its former playground at 357 Bellhouse Road.

Mr Percy Hall and Mrs Hall (headteacher at the National School) pictured with their family at 359 Bellhouse Road.

Mr and Mrs Drabble. Mr Drabble was the headteacher of the National School in the 1930s after the Halls.

Mrs Hall (left) and Miss Emily Rhodes (right), a form mistress with her class of infants at the National School.

Demonstrating that starting one's education in the National School could lead to greater things, here are five graduates from Sheffield University at their degree ceremony in 1928: left to right: J. Woodriff, who became chief draughtsman at Ed Pryor's; Ed. Waterhouse, chief engineer at Newton Chambers; H. Morris, who moved to Cyprus in 1929; George Warren, who became a teacher; and L. Parkin, about whom there is no information.

Below: *Miss Garrick and her class of children at St Hilda's C of E School in the 1940s.*

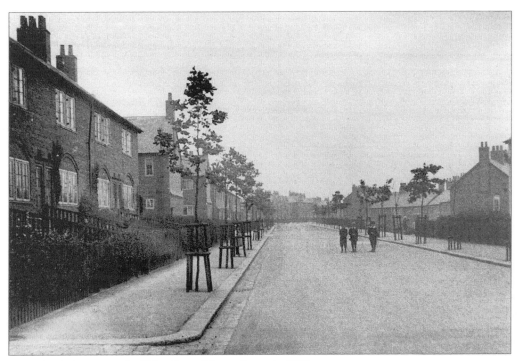

Wincobank Avenue on the Shire Green Flower Estate in 1928.

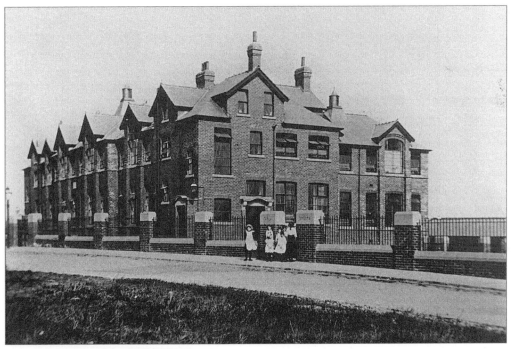

The new council school on Bracken Road in 1912. It was used as a hospital during the First World War. The headmaster was Mr Heath and the teachers were Mrs Sanderson, Mr Pashley, Mr Parish, Mr Trot and Miss Warr. The caretaker was Mr Simpson, who had been the caretaker for Miss Laura Ellis when she was headteacher at Malin Bridge.

These boys at Shire Green School, High Wincobank, took part in the display celebrating the Coronation of King George V in 1911: Reg Padley, Bill Croxon, Henderson Boast, A. Knight, Clarence Walker, Edgar Boast, Johnson G. Griffin, Alick Hemmingfield, Reg Ratcliffe, Percy Hunt, Ray Padley, Harry Croxon, Les Hemmings, Arthur Littlewood, ? Callis, Arthur Griffin, Harold Gilbert, Ted Feery, Ewart Ellis, Arthur Willingham, Jack Neal, Abel Wright, Ben Booth, Jimmy Ellis and E. Watson.

Shire Green School children, with Mrs Turton on the left and Miss Sylvester on the right, 1927. On the front row, third from the left, is Alan Tunstall and fourth from the left is Harold Roden; on the second row, fourth from the right, is Betty Brawn; on the third row, fourth from the right is Roy Baldock and fourth from the left is John Brunton; on the fifth row, fifth from the right, is Brian Hemmingfield and on the back row, fourth from the left, is Dennis Banham. Also in the photograph are Elsie Grimwood, Elsie Bailey, Gladys Gillam and Jack Smith.

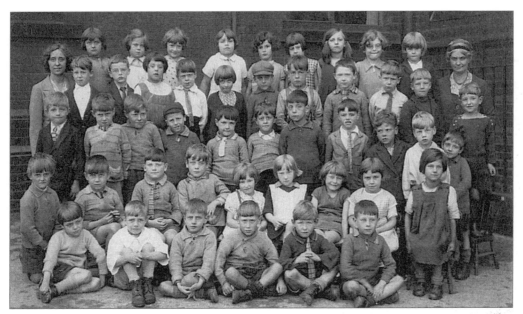

Jack Nugent's class at the Shire Green/High Wincobank School, c 1930. The 1930 class of forty-six boys and girls with teacher Mrs Barker on the left and headteacher Miss Dawes on the right. On the back row, fourth from the left, is Jean Burston, next to Margaret Senior. On the fourth row, fourth from the left, is Norman Moody; Leanora Hachet is in front of Miss Davis; Barry Pamplin is third from the right and Percy Roden fourth from the left. On the third row, second from the left is Tom Clark and third from the left is Joe Storey. In the centre is Desmond Brocklesby, with fourth from the right Stanley Betts. Jack Nugent is second from the right. On the second row is Jack Clark, twin brother of Tom Clark. Dennis Banham is third from the left and Ron Clayton fourth from the left. On the extreme right is Margaret Micklethwaite.

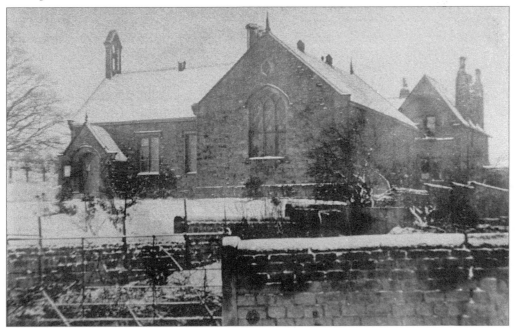

Winter at Wincobank Undenominational Chapel and school on Wincobank Avenue, opposite the little green.

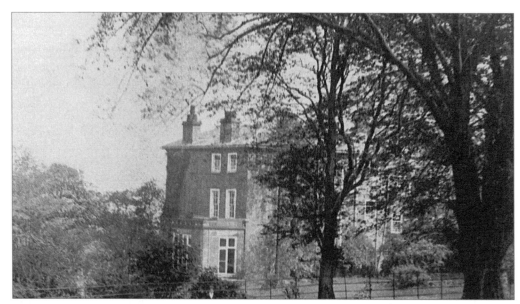

Wincobank Hall, near Sheffield, stood on Wincobank Avenue between Hyacinth and Clematis Roads. While in the ownership of Mrs Mary Ann Rawson, eminent visitors such as Robert Moffatt, father-in-law of David Livingstone the missionary in Africa, called to talk about their philanthropic work. Lord Shaftesbury spoke about children working in factories and mines, and William Wilberforce talked about freeing slaves.

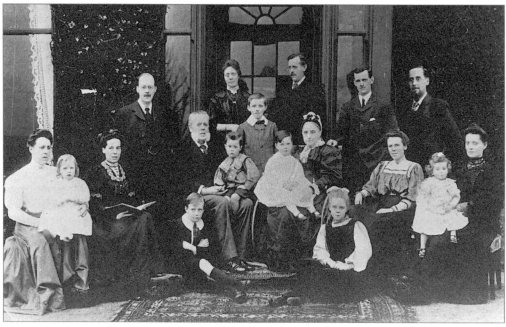

Wincobank Hall later became the property of the Wilson family, owners of the Sheffield Smelting Company. They too were philanthropists and benefactors. (Left to right) Helen Wilson; Oliver Wilson, who became Sheffield's Lord Mayor in 1914; Mr H.J. Wilson; Ronald Wilson (the boy); Cecil Wilson MP; Mrs H.J. Wilson. Seated are Joan and Donald Wilson. A member of this family became one of the last headmasters of Firth Park (Grammar) School.

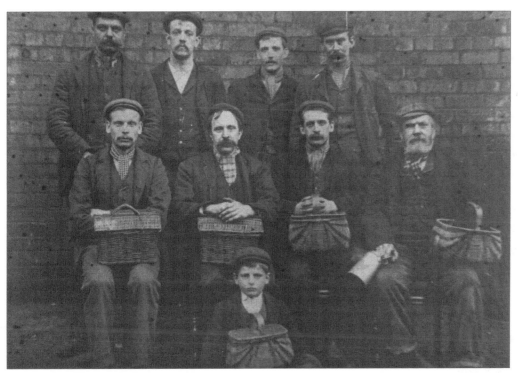

Some of the Shire Green workers employed by the Sheffield Smelting Company in 1920. Back row, left to right: Billie Hemmingfield, Walter Hazell, Bob Priestley, Cllr James Peck. Middle row: John Ernest Ellis, Frank Hutchinson, Jack Priestley, ? Garside. Charlie Cox is the boy at the front.

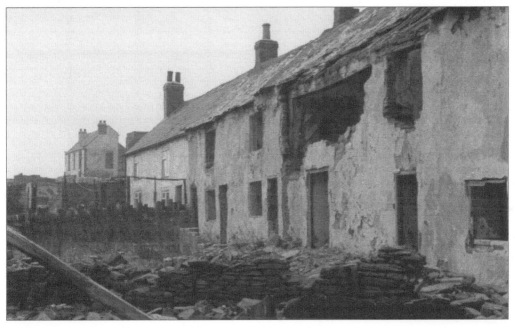

For almost 400 years these cruck-framed sixteenth-century cottages on Wincobank Hill had withstood the elements. Despite efforts to upgrade them, the two rows on Winco Wood Lane were demolished in the 1960s. In the distance can be seen Parkyn Jepson tower, known locally as Wincobank Castle.

Jenkin Road Methodist Church was built in 1911 on the steep easterly slope of Wincobank Hill, not a stone's throw away from Dearne Street.

The Dearne Street Methodist Church was built in 1898 at the foot of the hill where it joined Holywell Road. It closed in the 1970s and the building is now owned by Bowlan, The Ultimate Design Company. On the foundation stone are inscribed the names of the founding members: C. and B. Smith, ? Wilson, Miss A. Redman, Mrs Alfred Steel, Fred Garton, Mrs W.H. Godley, Mrs Foggleton, J.J. Aston, Mrs G.H. Crossley and A. Schofield.

Farm buildings at rural Top Wincobank, c. 1910.

By 1960 these much-renovated farm buildings, which had acted as a repair garage, were slowly being submerged under vast quantities of tipped debris from the local works. The tip later provided a platform for a filling station and repair garage near the top of Newman Road but this too has closed. Elsewhere on the flattened tip a large housing estate was built.

Ex-policeman Mr Berry and his wife in the doorway of their house on Wincobank Road in 1965. Their half-timbered sitting room used to be covered with beautifully polished horse brasses. They were regular attenders at the Shire Green Methodist Church.

The infamous Stone House on the corner of Leedham Road and Shire Green Lane which the Rawsons prevented being used as a public house.

The Shiregreen Working Men's Club on Shire Green Lane, proudly proclaiming itself as the 'Home of the Full Monty'.

6

A GROWING COMMUNITY

When the new chapel opened in 1883 there were only about 25 actual members but that number grew over the next seventy years or so to 150. The growth was steady and owed a great deal to the sacrifices of the dedicated few whose work had led to a situation where the chapel's activities could be maintained without undue strain on the finances or on the membership. If this thriving church could be traced from those faithful few of well over a century ago, it can also be traced from the tremendous work of the Sunday School over a parallel period from 1856. The Methodist Sunday School at the start of the eighteenth century was still a relatively new idea, established in 1769 by Hannah Ball, a friend and follower of John Wesley, in High Wycombe. It gave both girls and boys elementary instruction in reading and writing as well as in the scriptures. Wesley said in 1786, 'I find these schools springing up wherever I go. Perhaps God may have a deeper end than men are aware of. Who knows but that some of these schools may be nurseries for Christians?' He produced many cheap books to help this process of education.

There had been an endowed Church of England day school in Shire Green from about 1706, although the name of the founder is not known. In about 1720 Robert Turie made a gift of £40 for 'School purposes'. He did the same for the Parson Cross School, too. Both schools also benefited from the rent of a field at Wadsley, bequeathed by Ralph Hatfield in 1625 as his 'Dole'. It was only after 1857, with the erection of a new school building with an official playground in front of it, on land donated in perpetuity by the Duke of Norfolk, that daily elementary education became available to more children of Shire Green and district, many of whom had previously trudged to the Undenominational School by the Hall at Upper Wincobank. The schoolhouse off Bellhouse Road was also repaired, all at a cost of £460 10s 3d. After the rebuilding, the school hall was used by Dr Alfred Gatty, the then Vicar of Ecclesfield, for divine service on Sunday evenings, so that Shiregreeners could have a choice of service to attend. When St Hilda's Church was built on Windmill Lane in 1923 the little school was attached to this church until the school's closure. St Hilda's itself closed on 31 July 2005.

Within the Shire Green Primitive Methodist Society the establishment of a Sunday School was seen as the first priority. Once the new large brick-built church had been opened in 1883, the little stone-built chapel became the recognised Sunday School premises. It was crowded week by week, although the records of the early teachers and scholars have been lost. Mr J.G. Rhodes was the Secretary for some fifty years and his daughter Pattie succeeded him for another twenty-one years (1928–49), giving most valuable service. Another of the early Superintendents was John Ernest Ellis, who had married Mary (Polly) Ellis of the long-established Ellis family of Hatfield

Houses. A great cricketer who played for Shire Green, Yorkshire and Sussex in the late 1880s, he held office for twenty-five years. Arthur Knight was the Treasurer for many years, followed by Clifford Wragg, who served as both Secretary and Superintendent. Miss Nellie Woodriff was for a time the Treasurer.

The number of scholars continued to grow and the new chapel and the Reading Room Buildings across Winkley Terrace had to be brought into use to house them. The new school building was erected in 1938, and by 1956 all parts of the building were in regular use by scholars and teachers of a well-organised and graded school.

The upstairs hall housed the senior school. It had a stage and was well furnished with individual wooden chairs. On the ground floor the old chapel was transformed into the primary department, with wooden seats and some smaller children's chairs. Both rooms had an upright piano. Wooden benches from the old building stood against the longer two walls. Also on the ground floor adjacent to the primary department were the Minister's Vestry on one side of the corridor opposite the tiny kitchen and the Choir Vestry on the other. The Sunday afternoon Bible class conducted by Miss Doris Maycock also used this room. It contained an old pedal-powered harmonium which she enjoyed playing vigorously. She organised both Home and Overseas Missions for many years and strongly supported the scholars who collected regular subscriptions from friends and relatives in the hope of raising £5 or more each during the year in order to be awarded the coveted JMA DSO medal (Junior Missionary Association Distinguished Service Order) or the year bar.

The Sunday School has had a number of banners in its time and these were usually brought out for the Whitsuntide Walks around the district, a public demonstration of witness when children also paraded their new clothes. (The new outfits were usually shown earlier in the day to close relatives, who gave the child a 'Nip for new', a painful reminder that the new clothes were the result of hard work and much scrimping by the parents. The child was then handed a penny with which to buy some sweets to ease the pain.) The banner was also put on display at the Sermons, when it was placed in front of the chapel organ-casing. We know nothing about the early banner(s) but a new one, probably the second one, was dedicated in 1920 and lasted for thirty years. Another banner dedicated in 1950 still bore the 'old' name of 'Shire Green Primitive Methodist Sunday School – Established 1856' on one side, with a picture and text of 'the Good Shepherd' on the other. On Whit Sunday the banner was paraded along with the uniformed organisations, the Sunday School Queen and scholars, and teachers and members of the church armed with copies of the Sheffield Sunday School Union's hymn-sheet for Whitsuntide. They would walk around the district with drums beating and bugles sounding, pausing for breath at strategic points and singing one or two hymns before moving on. It was always hoped that Whit Monday would be fine and sunny because the same procession would set off at about 10 a.m., following a different route from the previous day, and make its way towards the junction at Firth Park where many of the processions converged and walked along Firth Park Road to take part in the great communal 'Whit Sing' in the park. Ever since 1813 the annual Whit Walk had been a major event in the life of the town and community. The only other event on such a large scale had been the annual Ecclesfield Hospital Parade that had ceased at about the time of the nationalisation of the Health Service. In recent years numbers attending the gathering in Firth Park gradually dwindled until the walks were suspended in 1996. Hatfield House Lane

members continued their witness on the open ground at the corner of Bellhouse Road adjacent to the Sunday School until 2005, when they returned to Firth Park in an effort to rekindle the tradition.

The Sunday School celebrated its first May Queen in 1932 with Margaret Sandall being crowned 'Queen Lily' by the Mistress Cutler, Mrs Ward. Mr Drabble, the School Master at the local Endowed Free School in Bellhouse Road, installed the first Captain, Kenneth Smith. The forerunner of this new ceremony was an Easter concert in the main church. After the building of the new upper schoolroom, the ceremony was enacted over three smoke-filled evenings to full houses following a play put on by the scholars. The crowning and the badging were performed by a different lady and gentleman at each performance and the Queen and Captain each received mementoes of the occasion. At the end of their year of office each was given a 'silver' pencil with their name and date inscribed on it. The Queen, after removing her crown of flowers, replaced it with a crown of forget-me-nots.

Unfortunately, some chapel members were alarmed by the pagan connotations of the May Queens and so in 1949, after sixteen years, the event was moved to October in order to be associated with the Harvest Festival. Queen Carnation III and her Captain consort remained in office that year for an extra five months. This was always a popular event in the life of the Sunday School and large crowds came to witness the ceremonies. The year 1992 saw the 60th anniversary of the ceremonies, and the event was marked by a procession of many previous holders of the office. From 1990 there had been no young men willing to take on the role of Captain, and from 1993/94, after Michelle Christer, there were no more Queens. Perhaps such roles had become outmoded concepts.

7

MEMORIES OF THE SUNDAY SCHOOL

BY DOROTHY WALTON, NÉE SHERINGHAM

I was three years old in 1925 when I started to go to the little Methodist Chapel Sunday School with my elder sister Margery. We lived at 310 Bellhouse Road, and so were practically next door. All our friends went too: Dorothy Jackson, Martha Hobson, Renee Williamson, Ivy Salt and Edna Cross. We all shared the joys of Whit Sings, the Sermons, the Christmas treat, chapel concerts, the Band of Hope and, of course, Sunday School morning and afternoon.

The Sunday School was the original little chapel of 1856 and I can picture myself walking in through the gateway – the gateposts and the surrounding wall seemed to tower above me then! I remember a wooden bench around the walls, long benches in the middle and a platform with a piano at one end. The piano was played by Miss Edna, that is Edna Horton, who lived with her parents and brother at 352 Bellhouse Road. In 1931 we moved into the next yard to the Hortons but during my childhood, the husband died, the son was killed when out on his new motorbike for the first time and then, to the devastation of all, Miss Edna contracted rheumatic fever and was buried on her 21st birthday. Mrs Horton was a gentle, sweet person and she and my mother were very close.

My earliest memories are of standing on a bench in the little Sunday School when I first started. (My big sister would put me up there, as she was rather bossy!) I was fortunate enough a few years ago to come across a copy of *Child Songs* by Carey Bonner. In it are all the lovely little hymns and songs we used to sing – 'When mothers of Salem their children brought to Jesus'; 'Tell me the old, old story'; 'Jesus bids us shine'; 'Hark, hark, the Christmas bells' and 'Hark, the Christmas bells are ringing' – and which I still sing around the house.

There was no building in those days between the little old chapel and the big church. When we sang, 'Jesus bids us shine with a pure clear light' and came to the words 'You in your small corner, and I in mine', I used to think it meant us standing in the four corners of that little grassy square. When it was time for the collection to be taken, one of us would fetch the small Gale's honey jar in the shape of an upturned bee-hive and let the children drop their coins into it through a slot in the lid. Everybody would be singing, 'Hear the pennies dropping, Listen while they fall; Everyone for Jesus, He shall have them all. Dropping, dropping, dropping, dropping; Hear the pennies fall. Everyone for Jesus, He shall have them all.' As far as I can remember we used to gather in the little chapel at morning Sunday School, then marched into the big chapel for the sermon, and then we came home. At afternoon Sunday School we went straight to the big chapel where our 'Star Cards' were marked and then we sat in our separate classes in the pews with our teachers. I always remember singing 'Now the day is over' at the end, as I knew – I'm afraid – it meant that we could go home but I would have to walk up our passage very quietly as Dad would be having his Sunday afternoon snooze. Mum used to put a

little pile of sweets for each of us on the table. We could go out for a little walk with our friends afterwards but could never 'play out' with any of our toys – Sundays were special!

One of our great joys was the Sermons when we sat on tiered seats on each side of the organ. I think this came just before Whitsun and that we sang Whitsun hymns but I cannot be sure of this. I do remember being on the top row at one time and looking down over the back and seeing someone 'blowing the organ!' Guest preachers came to the Sermons and as children our favourite was a Mr Whitty, who lived up to his name and made sure of making the children laugh at his jokes.

Whitsun of course was wonderful when we all assembled in Hatfield House Lane. I always felt so proud of our beautiful banner, especially when we got into the park, as I was sure it was more beautiful than all the others. The Whit Sings always seemed to me to be a cross between a religious service and a social gathering, as aunties and uncles and neighbours were met up with and ice creams bought. My earliest memory of the Whit Monday sports was running in a race in one of Crawshaw's or Ollerenshaw's fields (formerly Hawke's farm in Shire Green Lane). We went back to the chapel for tea, which was set out on tables on the grassy square between the little Sunday School and the big church, and we all received an orange and some sweets to take back to the field, where we played various games, one of which was 'In and out the windows'. It was all great fun. After our lovely fields were taken away from us to make Concord Park, it never seemed quite the same to be having our sports 'in the park'.

Harvest Festivals were also highly interesting. The table in front of the altar was covered with a large white cloth on which were displayed all sorts of fruit and vegetables and in the centre stood a flat loaf of bread made to look like a huge ear of wheat. It was made by Mr Allen the baker, whose tiny bakery was close to his shop on Windmill Lane. I remember stooks of corn tied round the end posts of the altar rail, which looked as if they were still growing. I also remember being in a field at the back of the houses at the very top of Bellhouse Road, where Oaks Fold Road is now. We played 'Here we go gathering nuts in May'. Round about the time of the Sermons, our Star Cards were handed in and the stars counted. Then we were given a list of books and told which category we could choose from. The books were presented on the Monday evening of the Sermons. It was all so exciting as we only got books on birthdays or at Christmas and we always treated them like treasured possessions.

On Monday evenings we used to go to the Band of Hope, chiefly because all our friends went. We made little mats out of wool and sang rousing temperance songs: 'Pull for the shore, sailor, pull for the shore. Leave the poor old stranded wreck and pull for the shore.' I thought this was very heartless because I believed 'the poor old stranded wreck' was a shipmate of the sailor! My dad always impressed upon us not to sign 'the Pledge' but as we were only seven or eight years old, I don't think it would have counted.

Concerts were very exciting occasions and though we were never chosen to be the May Queen, we had all the fun of the rehearsals and the importance of the actual performances. I also remember other concerts being given by amateur performers, and on one occasion our little group disgraced itself by having a fit of the giggles when a male soloist sang, 'Ta-ra-ra-boom-de-ay'. Of course, we thought he was singing another word which sounded very much like 'Boom!'

It is all a very long time ago but we have lively memories of quiet, innocent days in a completely different world and we retain loving memories of those dedicated teachers who, along with our mother, gave us the firm foundations of a faith that has stayed with us all our days.

From Shire Green to Oaks Fold

The site of Hawke's farm on Shire Green Lane.

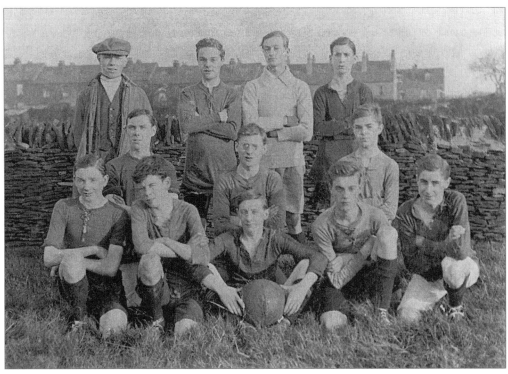

A Shire Green football team in front of the stone-walled field at the back of Hartley Cottages may be where Watkins' farm had been located.

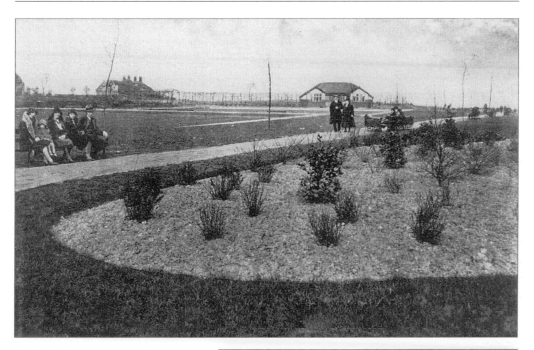

Above: *Concord Park, about 1933,
showing the bowling greens and
pavilion on the main path leading
from the wrought-iron entrance gates
towards Woolley Woods. On the
left, at the end of Oaks Lane, is the
barn of Yeardley's farm – now used
as a centre for the local environment
where the conservation group holds
monthly meetings – and Lockwood's
farmhouse.*

*Nellie, Joe, Ted and baby sister
Gladys in the back garden of their
home, 324 Bellhouse Road in
Broomhead Terrace which overlooked
the former Shire Green cricket field
that eventually became Concord Park.*

Ernest Wright in the garden of his terraced house at 319 Bellhouse Road. His garden overlooked Ollerenshaw's field, which became the sports field of Hatfield House Lane Secondary School. He was the Secretary of the little Methodist Church for thirty-seven years.

Below: *Aerial view of Shire Green, looking over Concord Park towards low Wincobank, Blackburn and Kimberworth Hill. One can see the extensions to the Hatfield House Lane Secondary School, the original layout of the primary school, the little church and Sunday School, the park's leisure facilities, the paths to Woolley Woods, the cloughs and fields, and Maycock's farm beyond the new Hinde House School with the gasometers at the foot of Kimberworth Hill.*

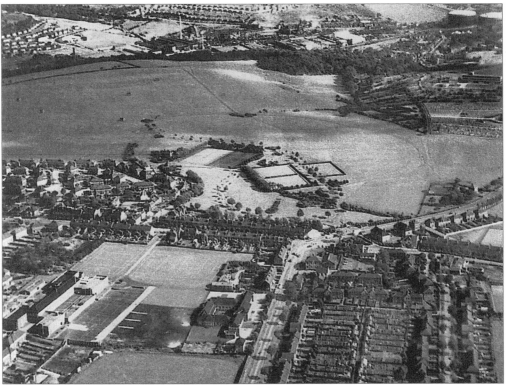

The refurbished cottages on Oaks Lane, looking towards Bellhouse Road.

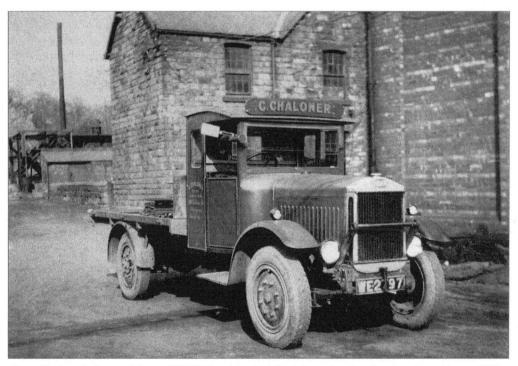

Clem Chaloner's first coal lorry, WE 2797, with which he delivered sacks of coal to the residents of Shire Green, fetching his supplies from Grange Lane railway station.

Above: *Mildred Hemmingfield's 80th birthday party in her front room at 6 Oaks Lane.*

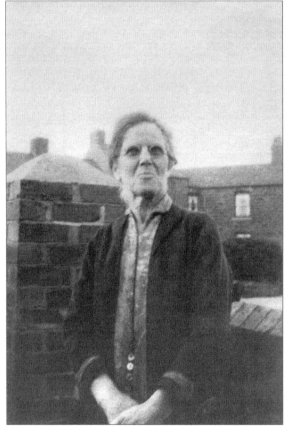

Miss Elizabeth Knight, aged 82, in the front garden of 6 Oaks Lane with the old cottages in the background. She was the daughter of Thomas Knight, one of the six founders of the Primitive Methodist Chapel at Shire Green.

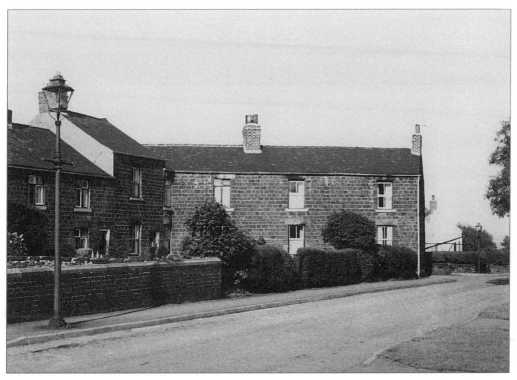

Oaks Lane Cottages looking eastwards towards Rhoda Green's (née Chaloner) cottage and the first clough where she used to go as a child to fetch clear water from the spring.

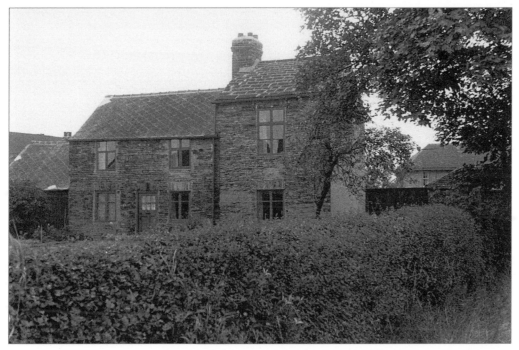

The cul-de-sac of Jacob's Lane, off Oaks Lane. There used to be a bowling green in front of this building, as the shape and size of the garden suggest. The Seven Stars pub stood across the way to the right.

Rhoda Green, Clem Chaloner's sister, outside her little cottage before it was redesigned after her death and enlarged to become Rock House.

Below: *Tastefully modernised and restyled in about 1960, this former two-storey fork-shop was added to the neighbouring property to make a splendid dwelling that still conveys something of old Shire Green. The fork-shop, worked by the Oxprings, was the last one in Shire Green to produce hand-forged forks. It was here that the very first silver-plated stainless steel forks were produced after much experimentation in the late 1920s.*

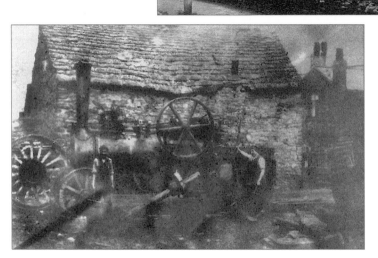

At the end of Oaks Lane stands the Cuthbert's steam engine that was used to drive the threshing machines.

Yeardley's farmhouse and the ancient cruck barn, used by the park attendants to house their equipment, and now used for conservation meetings.

Below: *Lockwood's farmhouse seen from the park. This was the farmhouse I would have liked to be kept as a Local Studies Centre, but to no avail. It has been demolished.*

The Anglican Church of St James and St Christopher was built for the new upper Shire Green estate. It ran a great youth club and put on some excellent dramatic presentations such as The Apple Cart *by George Bernard Shaw in the 1950s.*

Donald Naylor, seen here at scout camp, used to live almost behind the church at 32 Fircroft Road. He and I were firm friends, and he enjoyed his scouting at St Christopher's as much as I did the Boys' Brigade. He was so proud when he joined the cubs and could wear a special scout knife thrust down his stocking when on occasions he came to school in his uniform.

8

JACK NUGENT REMEMBERS

I well remember Charlie Bennet of Low Shire. He was born in Shire House where his dad was the gardener. His mother used to buy tablets of soap from Ralph Stubbins, who had a box fitted to his tricycle from which he sold all sorts of haberdashery and toiletries as he pedalled around the district going from door to door. He was disabled and frequently had to hop, step and slide as he tried to slow down his trike when travelling down hill. Mrs Bennet had enough soap hoarded up to last her through the war years, it was said.

We Nugents lived behind the Shaws down the lane alongside the Hollies, where the Motts went to live. I was born in 1924 on Nethershire Lane before the estate was built but had to leave at the age of 7 because the new estate required all farms and cottages to be removed. Our house had only one outside door so the council decreed that it had to be demolished. In the late 1960s the Shaws' house was renovated. There was a lane alongside our house which went down to Hutchinson's Croft. Bernard Shaw, father of Cissie, Kenneth and Mary, chopped up railway sleepers and other timber to make kindling sticks which he fastened together with wire and sold at a halfpenny a bundle from his horse and cart.

Dr Mole was in charge of Thundercliffe Grange when it was an asylum. Almost opposite the entrance on Grange Lane stood a house and some kennels. The owner had a horse and flat cart – a dray – but the harness was held together with bits of string and rope. Charlie Bennet's mother called him 'Puff and Blow'.

The bakery on Bellhouse Road at the corner of Windmill Lane belonged to Westmorelands before Mr Allen, a local preacher at the Methodist Chapel, acquired it. The Westmorelands moved to Nethershire but the baking of bread and cakes continued and late-night picture-goers returning from the Sunbeam or the Roxy cinemas could smell the dough being baked (and hear the crickets singing from beneath the ovens!)

The little shop next to the Horse Shoe Inn was a sweet shop run by Miss Dalton. Up Bellhouse Road Mrs Davenport opened a little general store in her front room. Her son Frank used to help Clem Chaloner from Oaks Lane deliver coal in the locality. It was said that Clem had his coal lorry thoroughly overhauled and repainted every three years.

Over the brow of the hill on the lower corner of Oaks Fold Road lived Mr Greenstreet the chemist. The next block was owned by Joe Gould. There was a fruiterer at the top end, Joe Gould's at the bottom end and an ironmonger between them. Gould's shop had belonged to Mrs Ward, who had scraped up enough money to open a shop by going round the developing housing estate selling cigarettes and sweets to the building workers.

Eric Greaves went from the farm on Hatfield House Lane to farm at Kimberworth, which still remained largely undeveloped.

NETHER SHIRE GREEN

Sam Knight lived on Nether Shire Lane and worked at Grange Lane station. In front of the window opening hangs a wooden shutter that was folded back during the day.

Below: *The orchard behind Farmer Mott's new house, The Hollies, off Nether Shire Lane, revealing the cottages near where Jack Nugent used to live.*

Old grinding wheels in the wall alongside Mott's garden and the former orchard.

Below: *An aerial view of the massive housing development that swallowed up the fields between Low Shire and Upper Shire Green quite quickly in the late 1920s. Nethershire Lane is on the extreme right, crossing Bellhouse Road at right angles and leading into Concord Road and Woolley Woods. Bellhouse Road leads left and forks left into Beck Road and right towards Grange Lane. Shire Hall Road is in the foreground, behind the fields. The farm on the right is Nether Shire Farm at the bottom of the common.*

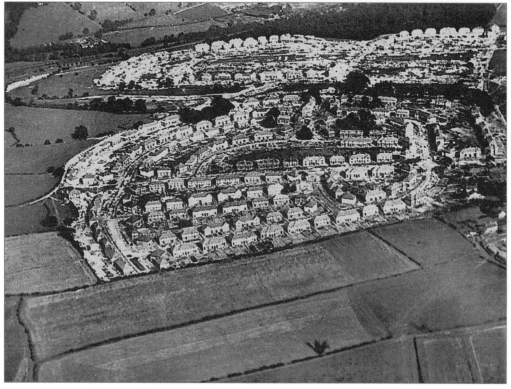

These stile stones on the footpath from the Plumps at Oaks Lane towards Nether Shire Lane allowed one to squeeze through when going across the common. A cow or a donkey often wandered on the common, where harebells, birds' foot trefoil and blackberries grew in abundance.

The west end of Nether Shire Lane ended at Bill Ellis's farm, where the 'smelly genyl' alerted walkers across the common that they were nearing the pig sties – or more likely the place where the 'midnight soil men' emptied their carts. In 1928 these children were given a ride on Billy Ellis's horse. They are (left to right) Dorothy Nugent; -?-; Teddy Taylor; Molly Ellis and Jack Nugent. The dog was called Lion.

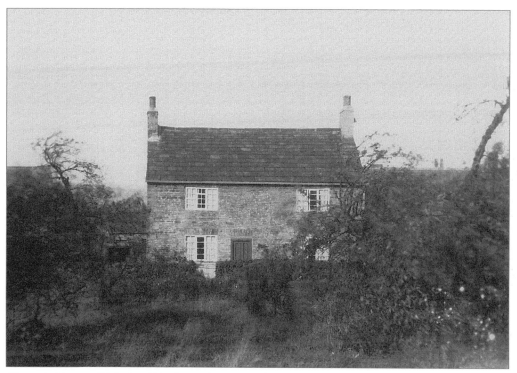

Nugent's House, off Nether Shire Lane, faced the track leading to Hutchinson's Croft.

Also off Nether Shire Lane there used to be an artificial lake in the extensive grounds in front of Ivy Hall. Mildred Hemmingfield's father is seated at the front of the boat.

The Low Shire Green Methodist Church at Beck Road opened in 1936 and closed on 31 August 2002 despite protests from its members who eventually moved to join with St James and St Christopher's or with Hatfield House Lane. The Girls' Brigade moved its activities to the local neighbourhood centre but no longer meets. The building stands empty but has recently been sold by auction to Sheffield City Council.

Up to 1956 the annual Whit Tuesday outings had usually taken Beck Road members by train from Grange Lane station but this was the first of many by coach. This trip to Clumber Park in 'the Dukeries' was much enjoyed because it was a favoured tourist spot.

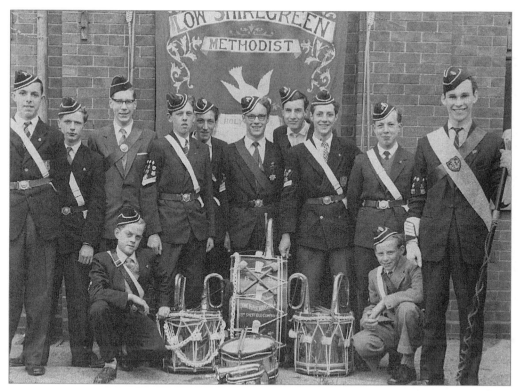

The 23rd Company of the Boys' Brigade, c. 1958. Left to right: –?–, Derek Tingle, a staff sergeant, a corporal, Gerald Wigley, Keith Stringer, Tony Powell, Corporal Malcolm Stringer, –?–, the Band Master and Staff Sergeant Geoff Barwick. Left of the drums is Ray Bedford and on the right is Ken Fielding.

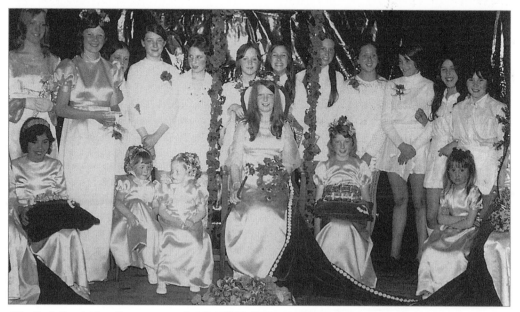

The Beck Road May Queen concert in May 1971. Back row, left to right: Sheila Walters, Linda Nolan, –?–, Elaine Ayton, Paula Morrell, Sharon Hickey, Kim Kynock, Jill White, Kathryn Makin, –?–, –?–, –?–. In the front row Karen Mosforth was Queen Anemone II, with Delia Ayton, cushion bearer, on her right.

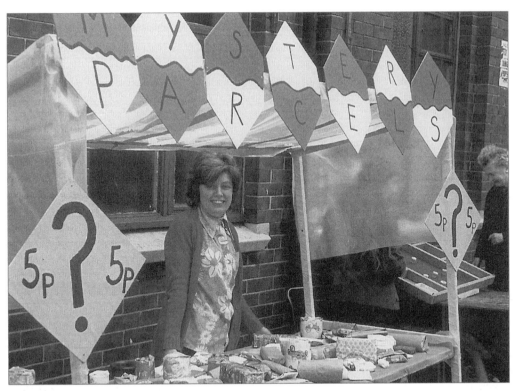

Doreen Ayton at the mystery parcels stall at the 1973 Beck Road summer garden party in the church grounds.

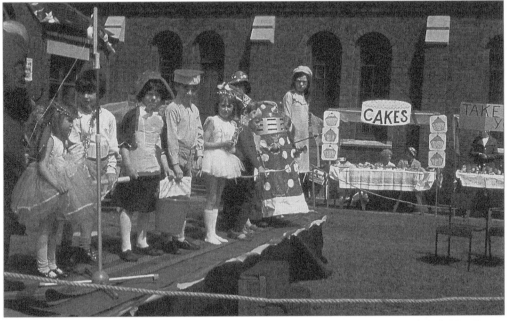

A children's fancy dress competition at the 1973 garden party. On show are a fairy queen, a boy with scroll, Jill and Jack (Craig Parker) with bucket, a ballerina (Julie Raines), an Indian brave with bow and arrow, a small boy, a Dalek and Kathryn Makin as 'the girl in blue'. Behind them is the ubiquitous cake stall, alongside the bric-a-brac stall.

9

LIFE IN SHIRE GREEN
BEFORE THE SECOND WORLD WAR

BY MILDRED HEMMINGFIELD

I was born in an old farmhouse at the west end of Nethershire Lane and, although I went to live elsewhere at the age of one, I returned there many times as it was the home of my maternal grandparents. The date 1716 was carved into the large stone above the fine fireplace and oven. Although no longer used as a farmhouse, it was typical of many in the area, having spacious rooms, stone-flagged floors, thick walls (sufficiently deep to take large cupboards) and wide window ledges, where my grandmother kept her beloved scented geraniums. Behind the curtains was a splendid hiding-place for my brother and me as children. We rejoiced in the fact that there was a well in the cellar, the bottom of which we never reached even with three broom handles tied together, so that there was no need to walk outside and toil for the precious liquid as my grandparents living in their little cottage had to do in the early days. And I never knew the well to run dry. But there was an outside privy. The house was lit by paraffin lamps hung on chains from the centre of the ceiling in the two large rooms, but otherwise we used candles, particularly to light us to bed. A wide staircase led upstairs to three large bedrooms.

Large stone tables in the store kept not only the usual family food but also flitches of bacon and hams which were heavily salted at the end of each year from pigs reared in the sties in the extensive garden. The kitchen or scullery was large, too, with a large stone sink and a draining extension also made from stone. There were ten in the family, father and mother and eight children – by no means an unusual number – so that the saucepans and the kettle (all made of iron) seemed huge when compared with those of today. Also vast was the tin washing bowl with handles and the earthenware 'peggy pot' for washday. In addition, great earthenware pancheons with their cream-glazed insides were used for milk and on baking days. How good the homemade bread, teacakes and spiced loaves used to taste.

Outside, the steps into the house were again of stone and very wide. No one grazed their shoe heels as they stepped down because they were tiered on three sides, and coming and going was remarkably easy. On a hot day they would comfortably accommodate a fine collie sheepdog at full length and two of us children as well. There was a ring in the wall for tethering a horse and lower down a file for scraping mud off shoes. Four longitudinal end windows looking out on to the garden had been blocked up at the time of the 'window tax' and two smaller ones inserted in their stead.

In addition to vegetables and flowers, the long garden contained herbs for use in the kitchen and for the treatment of human ailments. Later, at my home at 6 Oaks Lane, I kept a peony from this old garden blooming for another fifty years or so. It would be well over a hundred years old now. There were also some fruit bushes: red, white and black currants together with heavily laden gooseberry bushes, and an orchard with apples and pears, a few plum trees and a walnut tree. The hens lived here, too. We used to make blackcurrant jam, and hot water poured on to a spoonful of it in a cup helped mend coughs and colds long before Vitamin C was known. Across the yard, partly cobbled and partly mud, was a workman's cottage. It did not have such ample accommodation but still had a large living room and a garden for vegetables. The kitchen had a 'backstone' or 'bakestone' for making oatcakes on. There was a dog kennel, again of stone including the roof. Almost every building of any age was stone roofed, made of graduated pieces, narrow at the top and wide at the bottom and widest of all at the eaves. A little further up the yard were cow sheds in the shape of the letter L, and a pond at which the cows drank, often wading into the water. Almost every one of the farms in Top and Low Shire Green had a pond.

A cart track turning slightly north and south led both ways to a real farm, the Helliwell's. The entrance attracted many artists. To the left, after passing through a five-barred gate, stood a long open shed, again of stone, which sheltered the farm implements – not tractors, of course, but a plough, field rake, harrow and so on. Then, near the farmhouse itself, there was a large stone trough providing drinking water for the horses and the cattle.

The farmhouse stood firm and square, double-fronted with the door in the centre and facing the main roadway. Inside the date 1629 was carved on a stone on the stairs. Good stone flagging surrounded the house and part of the farmyard leading to a stack yard. The largest barn had several bays and was of the open 'Dutch' variety, always seemingly full of hay. Hens were plentiful and free-ranging. Good and healthy eating was the order of the day and it was not unknown for a fowl to be killed and brought in by the farmer for dinner. How quickly could one person then pluck, draw, stuff and cook the bird to make it ready for the table! The farmer and his assistant milked the cows and delivered the milk twice a day, the cows always knowing when to file into the yard and milking sheds from the fields. Milking was always done by hand as there were no machines. The farmer was his own deliverer and vendor unless he could get someone to fetch the milk. The cows were milked into a pail and the milk then poured through a large funnel with a piece of muslin cloth at the base to catch any bits of straw and manure (there was no pasteurisation or tuberculin testing) and then into large churns about 3 feet in height. These were lifted, heavy as they were, on to a milk float and held in position with leather straps. The 'float' was horse-drawn and the horse learned very quickly where to stop. The milk was drawn off through a tap at the base of the huge milk-churn into a milk-can, which was carried to the houses and the milk poured into a waiting jug or basin. What a number of times the milk was poured, and in the open street too, where dust and germs lay in wait. What a lengthy business it was, too. Still, it has to be said, the farmer earned more in ready cash from selling his milk than he did from the farm. I believe this is not so these days. During the First World War boys and girls began working on the farm at 10 years of age. One boy who was known to be only 9 brought a horse back alone from 'the Wicker' corn merchants in Sheffield all the way to Low Shire Green. A farm worker at

the time never received more than £1 per week for all his hard work. But his garden, orchard, fowl-run and pigsty, although hard going after a long day's work, gave him a better standard of living than the town dweller's.

In a Milk Survey of Sheffield and its environs in 1926–7, Mr Greaves, a farmer on Hatfield House Lane, Shire Green, received a special mention for his 'High Grade and Clean Milk'. He lived in the middle property of a group of buildings called Hatfield Houses, each owner claiming the title of 'Hatfield House'. The oldest part on the right, demolished in the late 1950s, was in part an ancient cruck barn. The quaintest building was on the left. Half-timbered, it dated from about 1500. The middle building, where the Greaves family lived, was the most modern, dating from the mid-1700s. This is most probably the house where the famous Sheffield antiquarian Joseph Hunter, author of *Hallamshire*, used to live.

Once or twice I remember my mother sent me to this farm with a lidded can for an extra pint of milk. I was fascinated to find on knocking at the back door that a light was switched on. This was my first encounter with electricity. Then a sliding door in the wall was opened and the milk – cool and fresh – was poured into my can.

To me as a child, cows didn't seem to have much intelligence, but one did suckle and rear a motherless foal, and another cow, having been sold to a farmer in Foolow, Derbyshire, found its way back to its old farm at Longley – quite a number of miles away.

At Helliwell's farm the stack yard led on to acres of good agricultural land. It was a great sight to watch ploughing taking place with one or maybe two horses pulling the plough, and to see how straight the furrows were and how neatly the ploughman manipulated the plough when he had to turn the horses round at the end of a furrow. I never went to a ploughing match but I heard of them and how exciting they were. After ploughing, wheat and oats were sown; turnips and potatoes were also grown, followed by seeds for clover and grass for hay. Young boys during their school holidays used to work in the fields 'singling' turnips or go potato or pea picking; sometimes they turned the hay to help it dry before it was made into hay cocks, or they helped to bind and stook the corn after it had been cut. Gleaning the stray wheat and oats was allowed and in this activity women also helped. A dear old aunt used to relate that what gleanings she gathered she threshed on a trestle with a rolling pin, then winnowed away the chaff on to a sheet by holding the plateful of grain in the wind. The wheat could then be boiled in water or milk to make 'frumenty' – a sort of porridge.

Many fields had their own long-established names. For example, there was 'Hutchinson Croft', the 'Forty Aker', the 'Two Lands' (or lads), and many more. As children we loved hay-making time although it was very hard work for the farmer. We would picnic in the hay field, play with the hay cocks and sometimes cadge a ride on the hay wagon. Nearby, across Hartley Brook, were the remains of old fields which had been worked on the feudal strip system and eventually became back gardens. I do not remember any modern chemicals being used except maybe lime to lighten the clay soil, and farmyard manure and 'night soil' brought out to the farms from Sheffield to add texture to the land.

Surplus milk was kept, the cream skimmed off and the rest fed to the pigs. The cream was churned into butter, either shaken in a milk can or churned in a wooden handchurn from which we could get 20–25lb at a time. My aunt Lizzie Knight often

compared this with the weekly 2oz ration per person during the Second World War. The golden yellow butter was weighed out into portions, pressed with a wooden hand stamp bearing the pattern of a cow, then placed on a clean cabbage leaf and sold to customers on the milk round. It looked and tasted good.

One of the local doctors doing his rounds always called on churning day for a drink of buttermilk. 'Beastings' (an old English word) was the rich yellow milk from the cow after the birth of her calf, and because not all of it was needed for the calf, the remainder was taken. It made wonderful baked custards. Any milk that had gone sour was strained, separating the curds from the whey, and the curds were then mixed with sugar and currants to become a pudding or curd cheese tarts – a great favourite of mine.

Several farms in the area were first farmed by the monks of Kirkstead Abbey Grange on Thorpe or Kimberworth Common. There was a grinding wheel for corn dated 1697 at Grange Mill Farm on Grange Mill Lane (sometimes called Market Lane) which was driven by the waters of the Blackburn Brook. The monks farmed right up to Oaks Lane and stored their grain in an excellent barn which is now used by the Concord Park keepers to store their equipment. It is an ancient oak-built cruck barn that was built by the local Anglian settlers of Anglo-Saxon descent about 800–900 AD in an area where The Oaks and Oaks Fold used to be.

A number of farms in the locality of Shire Green had similarly wonderfully constructed barns. One at Hatfield House Farm had a huge oak beam, the weight of which broke the cart carrying it away after demolition. A large stallion had to be used to haul it away. At Sheffield Lane Top behind the Pheasant Inn there used to be a single-storey corn mill. It was probably donkey-powered, as there is no source of running water nearby.

Quite a large portion of the land between Upper and Low Shire Green was common land, where horses, donkeys and even cows could graze. Down Sicey Lane just before Crapper House – the Ellises' dower cottage – there was a pinfold to house any straying or lost animals prior to their collection. Further along Hatfield House Lane there used to be a weigh house but that, along with much else, has been pulled down.

Shire Green, nevertheless, was true to its name and was a real part of England's green and pleasant land – until it was changed almost beyond recognition by the vast housing estates of the 1930s. And its future was again seriously threatened by the outbreak of war in 1939.

ECCLESFIELD

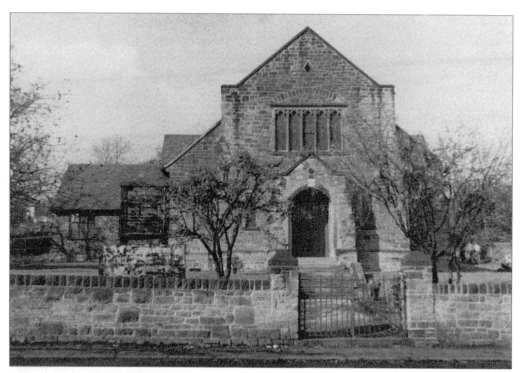

Ebenezer Church at High Greave, Ecclesfield, was built in 1926 and sold recently, following internal damage deemed too costly to repair. It is now used as a nursery.

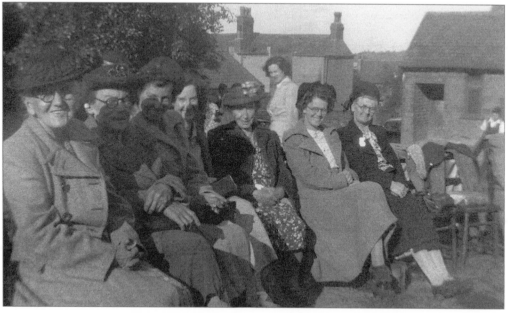

One Hatfield House Lane outing in the 1950s involved a garden party in the wild heath-like grounds at the rear of Ebenezer where we played games, paid forfeits, had fund-raising stalls and a splendid tea. Among those present were Mrs J. Edmund Hemmingfield; the second Mrs L. Overland; Gladys Woodriff; her mother Mrs Elizabeth Ann Woodriff; Miss Edna White and her mother Mrs White. Peggy Sykes, a fine pianist who married Brian Hemmingfield, is standing at the rear.

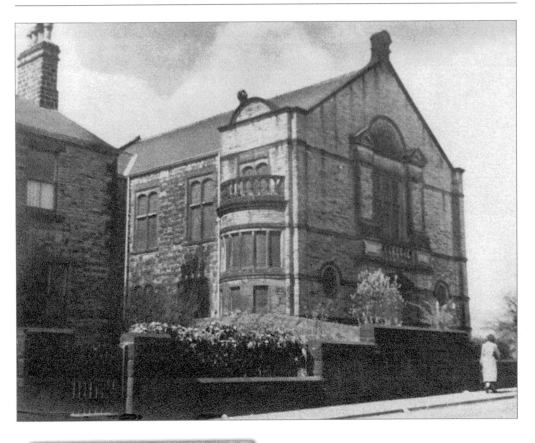

Above: *The principal Methodist Church in Ecclesfield is Trinity on the High Street, with ongoing worship and activities. It was built in 1897. The Manse is on the left.*

A Star Card for the Ecclesfield Sabbath School of the Primitive Methodist Connexion for the year 1919 and meant for Leslie Cooper of Johnson Lane but never collected.

Ecclesfield parish old churchyard, looking towards the trees and the former vicarage where the Revd Gatty and his family used to live. It, too, has been demolished and replaced by an up-to-date residence, although I and many others had hoped it might have become a museum to the Gatty family, similar to the one at Haworth for the Brontës.

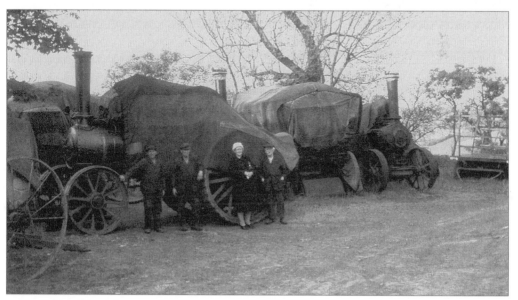

Having moved from Oaks Lane, old Mr Cuthbert and his two sons are pictured with Rhoda Green and their three steam tractors and threshing machines off Whitley Lane near their farm where they raised pigs in almost ideal conditions. They also made working scale models of their tractor and threshing machine which they took to steam rallies.

Sam Greaves (of the Greaves family who farmed at Hatfield House Lane) in his allotment field by Whitley Lane. The footpath from Priory Road and the church can be seen beyond the hedge.

10

THURSDAY NIGHT'S BLITZ ON SHEFFIELD, DECEMBER 1940

BY JOYCE BROWN NÉE MANIFOLD

Relatives and friends of people from Shire Green and Wincobank, as in many other parts of the country, often moved away to find work, or when they married, but they still remained in close contact, especially because when war was declared in 1939 the future looked so uncertain and the need for mutual support was so much the greater.

In Sheffield, a very visible part of the precautions for protecting the large industrial sites from enemy air-raid attacks was the number of 'barrage balloons' which were raised in strategic places. One such place was on and around the denuded Wincobank Hill where as many as seven could be seen on a clear day from our house. In 1940, my father took a picture for posterity of seven elephant-like balloons with their fat silver-grey bodies, large sticking-out ears and curled-up trunks, although they were really like the inverted tail of a clumsy aeroplane floating in the sky and tethered to the ground by a strong hawser as they protected the works in the industrial valley.

Our family, the Manifolds, was living at number 68, Osgathorpe Road, off the Barnsley Road, at the time when the Blitz began and in just those two nights of bad bombing, 800 people were killed and hundreds more lost their homes. My future husband, Vic Brown, his mother and father, his married sister Minnie and younger brother Donald lost all they possessed when their house and the one next door were bombed but Vic's parents, together with Donald and Minnie, went to live with their other married daughter, Lily Hicks. Vic went to lodge with some friends before he too went to live at Lily's.

When I had to walk into town to work, as there were no buses or trams running on the Friday morning after the blitz, the Wicker was a shambles. And over 60 years later, I can still close my eyes and see the scenes. A bomb had gone straight through the middle arch of the Wicker Arches and craters were all over the place and burnt out trams littered the streets all through town.

Sitting in the air-raid shelter during those two nights, we heard the noise of bombs and guns but until we eventually went to work, we had no idea of the devastation. A girl whom my older sister, Nancy, knew was never found and another girl, whom Nancy went to school with, was killed with her baby and everyone else in the air-raid shelter they were in. That was on Rock Street, I think. They were killed by the blast. And a girl I went to school with was killed in a later air raid about a year afterwards together with her mother, father and little brother, as well as the next-door family, just three roads away from our house.

For about three weeks we all had to walk to work. There was no electricity, gas or water for about two weeks. They came round with lorries and tankers. I think the gas returned first followed by the electricity but we had power cuts and eventually, I remember, Mum received a card which said at what times of the day and on which days there would be a power cut. So everyone coped. I don't remember being ill during the war until I got 'gout' – a sort of rheumatism – while working in the Women's Land Army.

In the morning after the Thursday blitz we were getting ready for work by candlelight when my father, a train driver, came home from work. We had all been worried about him but thought that his train would have been stopped outside Sheffield. I ran to the door saying, 'Oh Daddy, it's been a terrible night.' Dad looked at me and said, 'You don't know anything, Joyce. Walsh's, C & A and most of the town is on fire.' Of course we were shocked and appalled but Dad's train had been stopped outside Totley, somewhere near Millhouses. At one time, he and his fireman had to get under the engine and on another occasion, they had had to move another train out of the way. He said some firms were on fire. Laycock's Engineering Works and Stoke's Paint Warehouse were also burning. It was said later that a plane had gone down on Stoke's but there were always such rumours, I suppose.

There was a land mine stuck in a wall below All Saint's Church in Lyons Street. The house of my friend (and relative), Mary Merchant (nee Smith), and all the houses in the roads nearby had to be evacuated. I remember when I was about eight years old, we lived across the road from the Church and we all went to watch the new bells being installed and I remember as a small child sitting with other local children and my older sister, Nancy, in the back yard of some houses in Edgar Street about 1926 watching a 'Yard Play'. Eventually a naval bomb-disposal man defused the land mine. A few years ago, All Saints' Church was demolished and a modern and to my mind ugly one was put in its place. No-one seems to remember that a brave man had once risked his life to save that church but today's developers wouldn't think about that.

As a direct consequence of the blitz, I remember the day when our water supply was unexpectedly restored to the house water system. It must have happened on the night of the Manchester blitz when we had spent all night in the Anderson shelter from about 6.30pm till morning. Auntie was also living with us then. About dawn my Dad came home from work and brought us a jug of tea. At that time we had coal fires on which to boil the kettles and Dad said, 'We've got a flood in the house.' The water had been running for hours through the bathroom ceiling, down the hallway into the cellars. I've forgotten how deep it was in the cellars but Dad, Mother and Auntie had a right job clearing it all up when you think we had two coal cellars and a food cellar. I expect the ball-cock had got stuck through not being used. Nancy and I still had to go to work, so I don't think we were much help on that occasion.

Before the actual blitz, about the first bombs to hit Sheffield landed on the Pitsmoor Road district. Not many perhaps, just a lone bomber. Anyhow, some people were made homeless and because they could no longer sleep in their house until the roof was repaired, Mum took in three children from one family and the parents and the other children slept with neighbours. They used to come about four o'clock and go home during the day.

One particular night we'd been in and out of the shelter four times and had just got to bed when once more 'Wailing Willie' – the air raid siren – started. We had

Ann (Cousin Tom's auntie) with us as well and Auntie Gladys. We got in the shelter once more, a bit of a crush as you will imagine, but someone said, 'Where's Horace?' Horace had gone back to bed in my Mum and Dad's room, where she'd made him a bed out of two armchairs. Ann and I went to fetch him and all he said was, 'Damn 'em, Damn 'em', all from a little boy of under school age. Ann, while she lived with us, had brought up from London a little girl who was her boyfriend's niece. She married her boyfriend, Len Hatwell, a few weeks later. Anyhow, London was having a terrible time and Mum and Auntie looked after Len's niece 'Pixie' (her nickname) for a while. She was a sweet little blonde of about two and a half years, I'd think, and she used to sing when Ann was at work a little song or part of a popular song of the day called 'Oh Johnny, Oh Johnny, how you can love' but she got only as far as 'Oh Johnny, Oh Johnny, Oh GOD!!' I expect they'd sing it in the shelter and then it would be 'Oh God!' as they heard the bombs and guns go off. Two of Len's sisters also came but they stayed at his lodgings. They had needed a break and as we hadn't had our blitz by then, I expect they felt safer in Sheffield compared with London.

We also had two little boys to live with us for a few weeks. That was about the summer of 1944. It must have been at the time of the 'Buzz Bombs' – the V1 and V2 rockets – because Vic and I had married and I was already expecting baby Victor. (A trick at the time was to show someone a penny of George the Sixth and ask if they could find the 'flying bomb' on it; (the VI in his title was the correct response). A distant relative who lived in Owler Lane had a cousin and her family up from London while the husband stayed in London. They were with us in the November because we had a birthday party for Mum and Dad (11th and 26th November) and the boys also attended All Saints Boys' School. They were called Ian and Dennis. They were once in a play at school and Vic made Dennis a wooden sword. I think we found one of my hats and put a feather in it (a 'fevver' as Dennis said) as he was supposed to be Robin Hood or one of his merry men.

Going back to the Blitz: on Sundays the bombs concentrated on Attercliffe – the works – and the Pitsmoor districts. We'd had Gordon's family for tea as Gordon was home on leave, (but he wasn't at home that particular Thursday) so when 'Wailing Willie' sounded once more, we all stayed in the house as we couldn't all get in the shelter. There were Mum, Dad, Nancy, Gordon, Aunty Gladys, Mr and Mrs Meredith, Barbara, Jean, Alan (I don't think Gwen and her boyfriend were there) and, of course, me. I ended up under the living room table with the three children. Nancy and Gordon were on the cellar steps with Mum and Mrs Meredith, I think (and of course we had a bucket in the kitchen for emergencies). Well, after the 'All-clear' the Meredith family left to walk home to Shire Green and it was a long walk for them. Mum and Dad went up Osgathorpe Road to see what had happened as we could see the sky was red with fires etc. When they came back home, they looked as if they had come from the pages of the poem, the 'Pied Piper', and we ended up with the two sitting rooms and living room full of people. They had been evacuated from their street because of unexploded bombs and so on, and Mum seemed to find tea, cocoa or Camp coffee to hand round, even if we were rationed. I think they were so cold after their experience that they were glad to be indoors.

When we were experiencing the Thursday Blitz, I heard that Vic had had a nasty shock. He and a former girl friend had been to the pictures in town and they had to walk home during the raid. I presume he took his girl friend to her home first

but when he got to his home, he saw that it had been bombed. He spoke to an air-raid warden who said that there was no-one in the house and that they'd all be in the shelter. But they weren't. Vic persisted that his family must be in the house, which they were. They had been saved because the stairs had fallen across them and protected them while they were sheltering in the cellar. After the Blitz, Len Hatwell (Ann's husband) came to tell Mum that we mustn't go and seek shelter in our cellar because some people in Attercliffe had been trapped in their cellar during a raid. Later the Council came round to have little doors made between our cellar and next door's. So if one household got trapped they could probably escape through next door's.

An instance of co-operation between people and firms at the time of the Blitz was when W.H. Smith's, where I worked, gave space in their building to two 'rival' warehouses which had been destroyed. One was Turner's (near West Bar) and I think that the other one was Weston's (in Change Alley). At any rate, it enabled both firms to carry on with their own business without further loss. W.H. Smith's also gave £100 to a man who worked in their packing department because he'd been bombed out and the £100 would go a long way then.

Another strange incident happened when I worked at the MAP Firth Vickers. At this time we had moved next door and were living at 70 Osgathorpe Road. I had just come home off 'mornings'. It would be about 2.30 pm. Dad had only just gone to bed as he was going to work later. Mother had just mended the fire when a funny 'hissing' noise started. Well, you can imagine our first thoughts. 'It's a grenade in the coal!' Mother poured the kettle full of water on the fire. I, like a real coward, ran down the hall. Auntie went to the cellar steps . . . but it wasn't a hand grenade that was causing the hissing. We were a bit bewildered as more water poured into the fireplace and then we discovered that the boiler had burst. What a mess! Poor Dad had to be wakened up to turn off the stop tap but the water was by now running down the cellar steps making even more of a mess. We often had burst pipes during the winter but they didn't seem to cause as much trouble as this did because people were used to it with all the lead piping in their houses.

Despite the war and the blitz we still went to dances and cinemas. Dad always used to say, 'Where's your hat?' in the winter in case I got cold but he never stopped us from going out. I was only caught out once in town by the sirens when a friend, and a soldier we knew, had to go into the shelter under the Old Town Hall in Waingate.

We used to have a rota of fire-watchers on most roads. Nancy and I used to take our turn and it was a bit scary when we were not in the safety of an air-raid shelter but looking out for fire bombs (incendiary bombs) instead. We used to be very concerned for the Londoners but when I joined the Women's Land Army in 1941 I was sent to work at a farm at Potters Bar, and only when I went into London, did I realise what the Londoners must have suffered. Yet, seeing St Paul's Cathedral still standing surrounded by rubble and burnt-out buildings somehow gave me in a strange way a bit of hope. It was as if St Paul's was standing up for us all. Working near London I saw only a few aeroplane dog-fights while I was there. The worst air-raids were over by then until the 'Buzz Bombs' came. I couldn't see the planes, only the streaks they made across the sky and they were far away but the cowman told me that was what they were. And at night, the searchlights were a comforting sight to me when I was walking from the bus back to the farm.

When I used to work outside Sheffield it wasn't frightening in the black-out unless maybe you'd just been to see *Frankenstein* and *Dracula* in a double bill at the cinema, but I was frightened of the thick fogs we used to get. Twice in London I got lost in the fog at Potters Bar. One time, about 6.00 a.m. I went to bring the cows in but lost my way in the fog and the cowman had to come looking for me. It was so bewildering. Another time I had gone to call on someone in a road I had only visited once and didn't know the district or that that road was really a crescent. It was also near the railway and had a footpath by the side of the railway line. Luckily there was a set of signals at the side of the track but because the fog was so thick I just kept seeing their faint glow on my meanderings. Eventually I went to a house to ask where I was. They must have thought I was a bit dim but they pointed me in the right direction. I must have been walking round and round in the fog for over an hour on what was usually just a ten-minute walk.

In Sheffield, there used to be sort of propaganda weeks where one week it was 'War Weapons Week', then 'Wings for Victory Week' but I can't remember exactly the slogan for the Navy although it might have been 'The Navy's Here'. The bands from the different services whose week it was would appear and play in Fitzalan Square and other parts of the town and put on shows to let people see where the money they had donated had gone. For us in our teens it was all quite exciting to begin with until we heard that friends we had known had been killed or had gone missing and then we came down to earth with a bang. After Dunkirk we were able to watch the soldiers of the British Expeditionary Force who had got back to 'Blighty' as they changed stations, because our windows at W.H. Smith's overlooked Sheaf Street which connected the Midland (LMS) station with Victoria (LNER) so there was a lot of coming and going. It was all very depressing but those few days stayed in my mind as a hint of the sheer horror of what was perhaps to come. We didn't think that we might be defeated but we knew then that anything might happen. The husband of one of our friends had already been killed and that brought it home to us as Nancy's husband, Gordon, still hadn't got back to his own lines and had to wait another three weeks before he got out of France via St Valery. He said that it was only the rear guard of the 51st Scottish Division that had saved them. At the time Gordon was only 20 years old. He was to serve another 2 years and 7 months both in Gibraltar and then in Burma.

The blackout was a bit of a bind. The trams and the buses had little dark blue light bulbs to 'illuminate' the inside so it was of no use expecting to be able to read the paper while travelling at night. Thinking back, I often wonder how Mum managed to eke out the food. Dad had an allotment so vegetables were not a problem and we were all advised to grow our own. However should the 'grape-vine' hint that 'so and so' had some onions, there was soon a queue outside the shop. Later, when I got to know Vic's Mum, she would often pass over some margarine, tea or sugar. Our Wedding Cake was made from ingredients she had given us. We were lucky in that respect. A good friend who used to keep pigs also gave Vic a 2 lb stone jar full of pure lard and that helped with the buffet meal at our wedding. They had to forgo their rations of bacon and fat in order to get meal instead. But when it was time for the pigs to be killed, they were allowed to retain only one for themselves. We knew of one man, the mate of my friend's brother who also worked at the Firth Vickers MAP shop on Garter Street off Petre Street where I knew his sister and had worked

with her at Firth Vickers. Her husband was a stoker on HMS *Charybdis* and was killed when it was sunk. She used to live on Winco Wood Lane. Well, this man decided to sell one of his pigs that he had killed and was actually stupid enough to take the pork all cut up into joints in a sack past the Police Station in Waingate. He was taking it to where he was working 'on nights' but he didn't get to work that night as the Police stopped him and wanted to know what was in the sack. He was charged with 'black marketeering'. I thought I had better clarify the incident of the man and the sack of pork pieces. I remember that he was a mate of my friend's brother who also worked at Firth Vicker's MAP Shop. Vic also got to know this tale which went round the workforce. I have forgotten to mention that the house in which Vic's family lived before they moved to Smithy Wood Crescent (where they were bombed out) was at the bottom of Shirebrook Road and Albert Road, a site which was also bombed with eight people being killed. The Brown family certainly seemed to have a bomb 'with their name on it' but luckily for them they were not meant to be killed although we think it shortened Vic's father's life. He had been badly gassed in the First World War and always had difficulty with his breathing. Lily told me that if Vic had not insisted that his family were still under the rubble of their bombed house, she is sure her Mother and Father would have died there. The W.H. Smith's building was lucky, but the Brightside & Carbrook Co-operative Store building just up the road was destroyed – one of many. A bomb dropped at the side of W.H. Smith's but it went through the floor into the River Sheaf which runs under the road and goes into the River Don on Blonk Street. I believe the parcel despatch department – 'the deck' – had a bit of damage and a few cups broken but we were fortunate. The firm paid for all the staff to have injections against typhoid just in case there was an epidemic but there wasn't, although I still remember that I didn't like the injection.

I think I ought to let you know the 'secret' of MAP. It was a steelworks on Carlisle Street and Garter Street off Petre Street belonging to the 'Ministry of Aircraft Production'. It was where I went to work after I had to leave the Women's Land Army because of severe gout. We made cylinder sleeves for the aero engines for the RAF and had to check for the slightest traces of cracks and any 'inclusions', i.e. minute bits of metal or foreign bodies that might have got into the steel.

THE ENGLISH STEEL CORPORATION SPORTS GROUND

BY BRIAN BULLOCK

Although the Shire Green church had long been a centre of local community activity, as the population grew, so other attractions and leisure facilities came on stream and many events were organised, especially during and after the austerity of the Second World War. As well as the Working Men's Clubs, one other very important place was the Sports Ground and Pavilion of the English Steel Corporation, which was accessible via a turnstile by the main gates in Shire Green Lane or by the entrance in Bellhouse Road just above the 23rd Branch of the Brightside & Carbrook Co-operative Store on the opposite side of the road. When it was built in the late 1930s the pavilion became an instant attraction because of the enormous clock on its façade, by which many people set their own watches. It was no longer an acceptable excuse to return home late from playing in the park and say, 'I didn't know what time it was!'

Some of my earliest recollections are of the outbreak of the Second World War; so many memories were roused by an old photograph of the Sports Pavilion. It was built in 1937 at the ESC – formerly Cammell Laird's – Sports Ground at Shire Green Lane (often referred to as 'Bellhouse Road'), the destination of the no. 3 bus from Malin Bridge and the no. 150 from the City Terminus at Bridge Street.

This ground became the home for the sports activities of the English Steel Corporation after the amalgamation of Cammell's and Vickers in 1929, replacing the former venues at Carbrook (1911–17) and Tinsley (1920–5), which they had shared. The substantial grounds at Shire Green catered for a wide range of interests including cricket, association football, crown bowls, tennis, archery, men's and ladies' hockey, cycling, rugby and netball. There was a thriving angling section, as well as drama, chess, table tennis and billiards/snooker groups, and the Horticultural Society, the Staff Technical Society and water polo teams. The Annual ESC Sports Club Dance at the Cutlers' Hall could always guarantee a full attendance!

The war years saw many sporting activities relieving the hardships brought about by rationing and the restrictions on travel. We had to rely on buses and trams, and of course Shanks's Pony! The ESC ground was always a favourite with visiting teams, with its ample changing rooms (some with baths), large clubroom, bar and concert room, and well-maintained grounds. It also promoted annual charity cricket matches supporting the war effort and attracting large crowds – up to an estimated five thousand people.

Cricketing personalities were often guest players, and neighbours of the ground would often take advantage of their free grandstand view, watching from the comfort of a deckchair placed strategically on the roof of the bay-window at the rear of their houses in Shire Green Lane. Summers then always seemed to be hot and sunny and the Sports Ground a permanent attraction.

Sam Roebuck was the groundsman with the enormous responsibility for the preparation and maintenance of the pitches and playing areas. He ensured that no unauthorised feet trod on his carefully prepared surfaces. After Sam's retirement a quieter bespectacled gentleman by the name of Ernest took on the job.

In the new club room the redoubtable Mrs Thomas, seemingly always dressed in black, ruled the roost; like groundsman Sam, she stood no nonsense. Just let some 'innocent' try to buy a beer at the waiters' hatch on a busy Saturday night! She was a frequent visitor at 267 Shire Green Lane, the home of Mrs Gill, whose husband had been accidentally killed while at work.

Exhibition matches of table tennis, snooker and billiards were just a few of the activities in the Sports Club which I had the privilege of attending, at which I saw numerous celebrities of the time – nationally known sportsmen – taking part, as my autograph album will testify.

The annual Sports Gala Days with their numerous stalls and sideshows, supplemented by a Dutch auction or a boxing match in the evening, would attract large attendances and provide a grand day out in an age before television. Those were the times when employers like the ESC recognised the value of their workforce and when a levy of only a penny per week gave access to such a wide range of varied activities. The steelworks in Sheffield were heavily engaged in warwork and there were plenty of families living nearby who were looking for recreation and entertainment. The ESC catered for a wide variety of interests. Associated works in places like Darlington, Birkenhead and Openshaw in Manchester competed in various sporting events in the years before and after the Second World War, cementing the Shire Green Lane ground firmly in place as the jewel in the area's crown. Before the sad decline of the Sheffield steel industry there were as many as six thousand members of the club, with some twenty-six sections catering for their interests.

After the closure of British Steel, the grounds fell into a relatively run down and vandalised condition, even though some sections tried valiantly to keep going. Eventually the grounds were taken into the council's hands and the whole complex renamed Steel City Sports Ground.

Brian Bullock attended Firth Park Grammar School where he and I shared a fascinating extra-curricular activity – under the aegis of Dr Eker, the French Master – of making sure that the school tuckshop beneath the stairs in the library wing was fully stocked with coupon-free 2d fruit ices, 3d ice-cream blocks and choc ices, and a range of Cadbury's and Fry's bars of chocolate for which the appropriate coupon had to be cut from the page of the pupil's sweet-ration book. BW

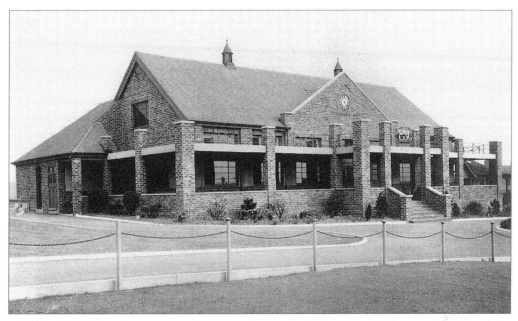

The English Steel Corporation's fine pavilion was built in 1937, the year of the Coronation of King George VI and Queen Elizabeth. The old Cammel-Laird's wooden pavilion can be just discerned behind the right-hand wall.

An official postcard view of the splendidly if spartanly furnished pavilion interior, with Mrs Thomas by the table.

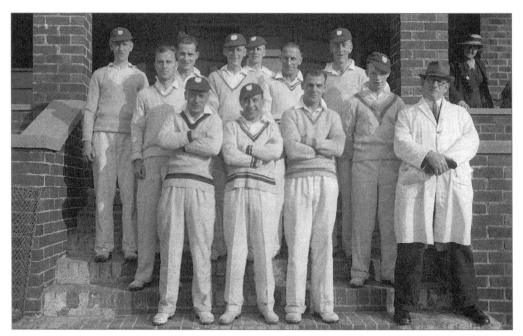

The ESC cricket team in the 1940s. Back row, left to right: Matt Cooke, Harry Wastnidge, Ernest Bullock, -?-, Bill Norman, Ernest Robinson, Jack Spencer and Bill Grant (umpire). Front row: Bill Holland, Harold Booth and Bill Jarvis.

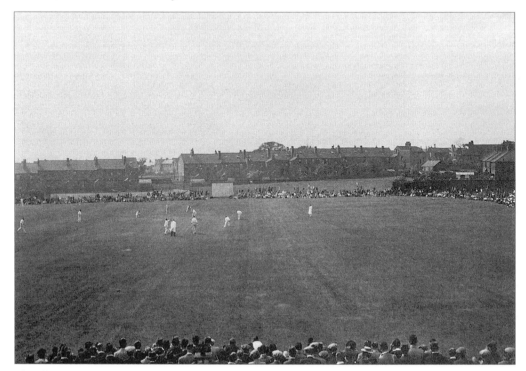

A well-attended cricket match on the ESC ground in the 1940s viewed from the pavilion looking towards Bellhouse Road with the houses on Shire Green Lane on the right. In the top right-hand corner the small workshop of the builders Rhodes & Mitchell can be seen.

The ESC cricket programme for July 1943.

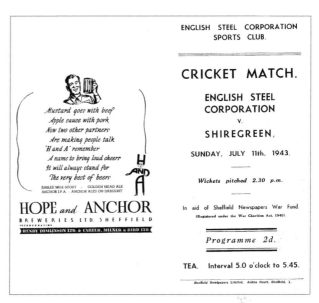

Below: *Brian Bullock's father was captain of the ESC team, which enabled him to get this list of autographs from most of the participating players in July 1943.*

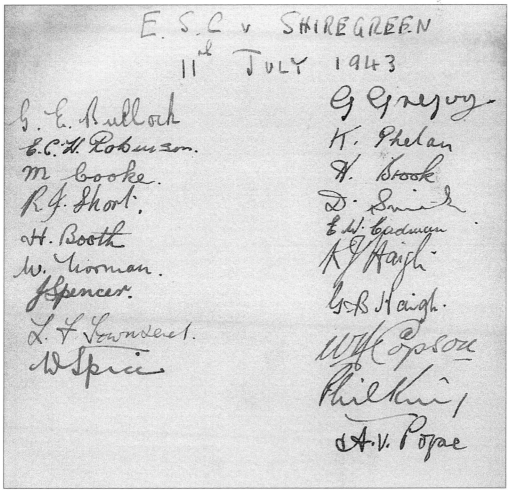

At the west end of the ESC ground on Gala Day, Joe Grant watches over his Hornby Railway game-of-chance on the Model Railway stand, observed by another colleague in the striped tent.

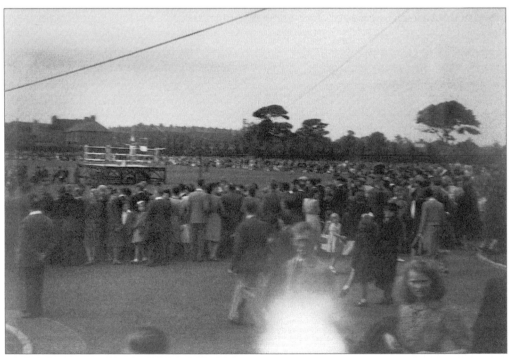

At the end of the day's events, a boxing tournament was sometimes held on the sports field to keep the visitors happy after the Gala.

12

FIFTY YEARS OF CHANGING FORTUNES

After the large-scale housing developments in the first half of the twentieth century, several working men's clubs appeared on the scene. A large purpose-built club arrived opposite the Wincobank Brick Company's yard down Shire Green Lane; another one took over the old Hartley House on Bellhouse Road near the Horse Shoe, and a third acquired the old house of Maud Royle the singer and brother to Stanley Royle, artist, also on Bellhouse Road almost opposite the Church of St James and St Christopher. At the Sheffield Lane Top end of Hatfield House Lane, the new club extended right up to the existing dwelling house which had once belonged to the Wragg family. Sadly there seemed to be no communication any longer between these communities and the church but at the Hatfield House Lane church for several more years life seemed to follow the usual calendar of events, although from 1956 the church on Winkley Terrace began to experience the pressures of trying to maintain its Christian witness in the face of greater leisure time at the weekend and other attractions/distractions increasingly provided for a growing non-churchgoing public becoming fascinated by the availability of television entertainment in the comfort and warmth of their own homes. Members of the Shire Green Community Centre (which had occupied the old Reading Room premises) were often seen at church services and events. The Sunday School anniversary in June was always a notable event, at which stepped platforms used to be erected high on both sides of the organ casing to seat several rows of neatly dressed children on a deep crimson-coloured material that effectively concealed the construction. In the early days – before the new 1883 chapel was built – the anniversary celebrations used to be held in a marquee in the field adjacent to the Shire Green Cricket Ground, where Hatfield House Lane First School now stands.

In my mind Shire Green and music have always been inextricably intertwined. Our life at home seemed to revolve around activities at the church. My memories are of the congregation and choir singing in chapel, and particularly of my mother always singing as she went about her daily housework, practising excerpts from Edward German's *Merrie England* or some other production for which she was rehearsing with the Victoria Hall Choral Society every Friday evening. Her singing filled our house and our early lives with a love of music, even though we didn't have a piano. It was a day to remember when we acquired our first gramophone. At primary and secondary school, at Sunday School and on the wireless we were introduced to more music by good composers and we learnt songs and hymns, folk tunes and dances which played a fulfilling part in our later lives. Before parting with the house at Shire Green I invited my friend the singer, Zoë Richardson, to give a recital of her spiritual compositions from her album 'Wherever I go' and refill the

empty rooms with the sounds of her music – a fitting farewell! At school we took part in the choir and attended concerts and recitals at church, school and concert hall and thoroughly enjoyed the experience. Participation made everything much more enjoyable so it was no hardship to attend the Band of Hope, perhaps the

oldest of the youth activities allied to the work of the Sunday School at Shire Green. It used to meet on Saturday mornings for talks and lantern-slide shows and the inevitable singing of rousing choruses. When it started, it was ably led by the teachers from the Sunday School. Its first pledge, which echoes Wesley's teaching, was to abstain from 'drinking, smoking, gambling and snuff-taking', and Mildred Hemmingfield devoted many years of her life struggling to maintain the temperance witness. She was never happier than when she was talking to children about temperance or introducing them to the magic of botany and biology. Notable among her predecessors were F. Hutchinson, J. Rhodes, E. Hemmingfield and J.E. Ellis who had given great support. The Band of Hope anniversary was another important event, as was taking part in the Gala Day processions around the streets.

Badge given to Members of the Band of Hope.

Part of the teaching involved annual temperance knowledge examinations. Shire Green has held both the Bailey Cup and the Lady Fisher Rose Bowl, no mean distinction for so small a company. Honours have also fallen upon the Band of Hope at Shire Green, in that four times Sheffield's Queen has been chosen from its ranks, namely Velma Furniss, Pauline Rawson, Roma Cooper and Kathryn Nodder. In the wider sphere Velma, Roma and Kathryn also served as Yorkshire Queen. Pauline Rawson was Centenary Queen for Sheffield in 1955 which entitled her to attend the centenary celebrations at the Royal Festival Hall in London. In the same year Velma Furniss was the Band of Hope representative in Norway. All this meant that Shire Green played a notable part in the life and work of the Methodist movement. Miss Mildred Hemmingfield had a copy of 'A Knight's Prayer' hung in the Primary School and exhorted all to learn it and stand by its principles. The work was continued until the 1980s with Hotshots which was a follow-on from the Band of Hope but lasted for only a short period until the section closed down. Nevertheless, nationally the important work has been continued into the twenty-first century by the charity Hope UK, which is following the Band of Hope tradition of putting the well-being of children first.

The work of the Sunday School was spread in other ways by the introduction of the uniformed organisations. There had been a Boys' Life Brigade Company (the 48th) at the time of the First World War but this had lapsed well before the late 1930s when Ron Brookes, somewhat envious of the fact that there was a Boys' Brigade Company at Firth Park, began to urge the two church stewards, Mr A. Burgin and Mr C. Wragg, to do something about starting a company at Shire Green. Most of the local nonconformist churches had both boys' and girls' companies at this time. Ron was then only 17 years of age and too young to be nominated as Captain. Apparently a church had to have a church member willing to be nominated as Captain before a company could be enrolled. Fortunately, Mr Ridgeway, an RAF serviceman stationed in Concord Park, had just started attending morning services. When he learned that

the church was interested in forming a company, he volunteered to be Captain. The first parade night of the newly organised 37th Company of the Boys' Brigade took place in September 1939. Mr Ridgeway was Captain for only a short while but enrolled 18 boys and 5 officers. He was transferred to other RAF duties in 1940 and Doug Gould took over. He remained in post until 1944 when Ron Brookes succeeded him. A junior reserve unit called the Life Boys was formed in 1939 under the leadership of Mrs Brenda Gould and Miss Eva Broomhead (later Mrs Brookes). After the war the company had an excellent band of bugles and drums encouraged by Lieutenant Brian Hemmingfield, who also ran classes in first aid. Lieutenant Norman Sutton taught semaphore and the Morse code for signalling proficiency and Lieutenant Cyril Brown, recently returned from army service, put the boys through their paces at drill to the extent that the squad failed by only ½ point to win the Sheffield battalion drill competition. In 1951 there was an important exchange of about twenty members of Sheffield's youth organisations with young people from our twin town of Bochum in West Germany and Bryan Woodriff was selected to represent the Sheffield Battalion of the Boys' Brigade. In 1960 there was a report in the local newspaper about the 21st Anniversary celebrations of the company which revealed that six of the seven officers in the 37th at that time had all been boys in the same company and had a total of 129 years of unbroken service between them! Mr D. Gould, the Commanding Officer of the 1st Melbourn Company, returned to Shire Green to be the guest inspecting officer for the occasion. It was not uncommon on Parade Sundays and at Whitsuntide to see Winkley Terrace filled to capacity with almost a hundred boys and girls, together with about 12 or 14 officers, all in uniform and ready to march off round the district behind a strong bugle band. Mr Brookes, who had joined in 1939, remained Captain until 1962 and after a break of three years returned in 1965 to resume the captaincy until 1981 when he handed over to his son John, who was succeeded by Mr D. Newbould in 1982. The Boys' Brigade members took part at this time in the local distribution of the Scouts' Christmas postal deliveries, but as numbers were falling the company section had to close down, leaving just the junior and anchor sections to carry on for a few more years. Eventually the company closed down entirely in 1997 and hung up its Colours in the church.

In September 1966 the Life Boys had become the junior section of the Boys' Brigade but retained the 'sailor' hat until 1970 when the Brigade was reorganised into three sections – junior, company and senior – all with new uniforms. Mrs Ena Sinclair had charge of these sections about this time. It wasn't until 1982 that an anchor section was added for 6–8 year-old boys. They have all done fine work for many years and provided a vital link between the Sunday School and the church. David and Robert Newbould were the last leaders of the junior and anchor sections when they closed down in 1997. Unfortunately, it was the serious problem of a lack of younger adults, willing and able to take on a regular commitment, which had forced the 37th Sheffield Company to close, and not the lack of boys. The many stringent regulations concerned with the protection of young people are also affecting the continued viability of many voluntary uniformed youth organisations. Ron Brookes said, 'We can look back with pride and pleasure at our very active past but should strive to serve the community of the present with energy and devotion to keep abreast, if not ahead of the times.'

Youth work still prospers today in the capable hands of the 25th Sheffield Company of the Girls' Brigade, established in 1965. Formerly known as the Girls' Life Brigade, it was affiliated in July 1941 with Mrs Dorothy Talbot as Captain. She had three lieutenants: Miss Winnie Moon, Miss Dorothy Harness and Miss Doreen Brookes, who was promoted to Captain in 1943. She held that office until she handed over to Mrs Pauline Thoday when she was promoted to Commissioner. Their work centred on the yearly camp and their bi-annual conference at Hope in Derbyshire. Another great event annually was the Albert Hall Rally in London. In 1952 Sergeant Janet Chaloner presented the Sheffield and District's Birthday cheque to HRH the Duchess of Gloucester. When HRH Princess Margaret visited Sheffield in 1949 Staff Sergeant Doreen Crabtree and Mrs Doreen Sylvester (née Brookes) were among the twenty chosen to represent the Brigade in the Guard of Honour.

Various trophies have been won over the years, including the junior and senior PT trophies and the junior, senior and pioneer national dancing trophies. The annual division parade every October also used to be a notable event. Many girls have passed through the ranks. At present, with explorer, junior and senior sections still meeting on Monday evenings, the Girls' Brigade is strong numerically and much valuable work is done through this lively organisation. It meets under the leadership of Linda White, helped by Pauline Thoday, Ann Newbould, June Rains and Rita Bell, with Ann Scott and Kay Walker as auxiliaries.

Another youth organisation, this one non-uniformed, was the Christian Youth Fellowship. It was formed in 1943 with the Revd Masters as its President and a committee of eight church members: Laurie Smith, Mrs Gladys Brookes, Mrs Lily Rhodes, Louis Overland, Douglas Gould, Ron Brookes, Archie Burgin and Ernest Cooper. When the Christian Endeavour section merged with the new Fellowship, Ruth Wragg also joined the committee and Frank Rhodes and Will Brookes joined by invitation in May 1943. In 1949 both Will and Gladys Brookes resigned and this allowed Clifford Bilson on board. Laurie Smith's daughter Pat said it was a great disappointment that when the Fellowship was in existence in the 1940s she was not yet 14 and so was too young to join. By the time she could, she was no longer interested, even though her father was Convenor and Secretary. He made a point of voluntarily spending at least part of every Tuesday and Thursday evening at the Fellowship. Such people felt they had a duty to dedicate time and effort, without being paid, to the well-being of the younger generation. Dedication of such magnitude is rarely seen today.

Pat often accompanied her mother when she went along to help Mrs Brookes, the mainstay of the kitchen, from where she served refreshments. As a treat Pat was allowed to count out the biscuits into pennyworths. She remembers looking forward all day to going out in the evening.

The Fellowship provided recreation and companionship in a way that was different from the church's other youth activities. It was started by the Revd L. Brown before he left and nurtured by Laurie Smith, who gave much of his time and energy to this work. Although it lapsed for a period it was revived and went on to do splendid service on Tuesdays and Thursdays for many of the young folk in the area. At one point it had a hundred members and a waiting list, and from its membership were formed a good football team and a cricket team. The football team played in the Sheffield Bible Class League and was managed by Percy Roden. Ron Brookes became

Secretary of the Hatfield House Lane cricket team which was accepted into the lowest (3rd) division of the Sheffield & District Sunday School Cricket League in 1950. The team gradually progressed through all the divisions until finally it became Champions of Division 1. The club's home ground was on the mound in the lower half of Concord Park, just above the golf course. Sadly, the close-boarded wooden changing huts for the teams were destroyed by time and vandalism so the cricket team began to play on the former ESC sports ground, but no longer as the Hatfield House Lane cricket team. Instead it became the 3rd team of Shiregreen Cricket Club, with which it merged in 1989.

As long ago as 1918 the little chapel felt that the women of the village who were unable to attend the Sunday services because of domestic duties might like to have their own meetings. So the Sisterhood was formed. Meetings were held on Monday afternoons. In those early days it was hard caring for large families on low wages and the preparation of the Sunday dinner was an onerous duty for the mother, as well as an occasion for all the family to gather round the table and sit down together for the day. The Sisterhood gatherings provided an opportunity for the women of the chapel and village to meet, gossip, listen to a speaker, worship and enjoy a cup of tea together. For twenty-five years Mrs Knight was the Secretary, Mrs Pritchard the Treasurer and Mrs Adams the first President. The Sisterhood began with some twenty-five members, but this figure soon increased to sixty or seventy. Membership dipped during the war years but subsequently the group regained some of its former strength. Under the secretaryship of Mrs Townrow, then Mrs White and later Mrs Overland, the Sisterhood was one of the most vital groups at Shire Green. In its time it has been the source of many gifts to the Sunday School, the church and to many other good causes through its bazaars, sixpenny teas, jumble sales and so on. There has always been a high level of spiritual fervour; the fellowship is rich and the devotion warm, and such things as birthdays and personal anniversaries are noted week by week. Their annual anniversary is a great inspiration to all who share it. The celebrations spanned a whole weekend, with a concert on the Saturday evening, often given by the members. When Mrs Eva Brookes became the Secretary of the Sisterhood in 1963, she acquired an old Minute Book and a Register dating from 1951. In a talk she remarked that the Minute Book stated that one year the entertainment was provided by the 'Black and White Minstrels' – but not the professional ones, she thought! Annually there is also an outing, an early innovation, and this has been a source of real pleasure. Members paid into the Outing Club so much each week according to their means. The annual outing to Lincoln was started about 1956 with the Hykeham Church people interchanging with Hatfield House Lane members. The scheme lasted for twenty-five years. Wandering around the city and having lunch before going to the Rally was always a delight. The welcome in Lincoln's Moor Lane Village Chapel was always warm and friendly. Other outings went to London, to Wembley for the 'Ice Show' or to the theatre for a musical.

The Minute Book of 1951 tells us that the President then was Miss Pattie Rhodes, in whose memory there is the clock on the Primary School wall. The various vice-Presidents have been Mrs Steggles, Mrs Townrow, Mrs Talbot and Mrs Frank Rhodes. The Secretary was Mrs P. White. The rest of the committee consisted of Mrs Overland, Mrs Hindley, Mrs P. Smith, Mrs Mitchell and Mrs Eva Brookes, not

forgetting Mrs Furniss, the Treasurer. The pianists were Mrs Hanson and Mrs P. Smith. There were eighty names on the register that year and they were meeting in the same small room. The names of many of those regulars have been embroidered on to the tablecloth which is used at every Monday meeting. That tablecloth holds many memories of loyal and steadfast ladies working and living for their Monday meeting at Hatfield House Lane. Their influence on the church and its members was great and they set a fine example to many.

The Women's Friendly Hour was of more recent origin, and was in some ways a branch of the Sisterhood work. It was designed to serve those women with children under school age. They brought their children, who sat on the windowsill and sang 'Jesus wants me for a sunbeam' and 'Jesus bids us shine' – when they weren't making a din in the middle of the floor! This proved to be a most helpful service, and it continued under the benign leadership of Mrs Frank Rhodes until 1966. In 1963 the name changed to the Hatfield House Lane Young Wives' Group and in 1999 it became The Ladies Fellowship, which meets on the 1st and 3rd Tuesday evenings of each month. It still makes a vital contribution to the life of the church and many are drawn to the meetings.

The choir was always a distinctive feature of the church. In the early days the Shire Green singers were noted for their performances in oratorios and cantatas and, like their Ecclesfield neighbours, were held in high regard for the quality of their singing. In competition with other churches Shire Green earned a number of worthy trophies. Mr John Gregory was associated with the choir for many years at the beginning of the twentieth century, and later Mr Lewis Overland served most loyally as choirmaster after Mr Gordon. The choir used to meet on Wednesday evenings but always stopped practising for a few minutes to listen to the Life Boys as they knelt to sing 'like angels' their Vespers in the upper schoolroom.

In 1999, while the choir vestry was being tidied in preparation for the new kitchen extension, a 1972 newsletter was found that contained an interesting short history of the choir. 'The time was when training for the choir began in childhood. Mr Edgar Ellis Hemmingfield, father of Brian, had a beautiful deep bass voice but he remembered joining the choir as a boy alto. His memories of Church services were always from the Choir stalls. He used to relate the story of how, during the early part of the 20th century, the Choirmaster, Mr Gregory, used to go straight to the church from work, have his tea and then rehearse the children, accompanying them on his violin. He would listen to each child in turn to make sure that no-one was out of tune.'

Music played a big part in the musical life of the church and it was customary to give Handel's *Messiah* just before Christmas, Mendelssohn's *Elijah*, Haydn's *Creation* or another such work at Harvest Festival, and at Easter, John Stainer's meditation, *The Crucifixion*. For all these events, and for Sunday School anniversaries, a full orchestra was used as well as the fine organ to accompany the choir and the invited vocalists. Each church in the circuit had its own dates for musical events which were strictly adhered to so that one could help another. In more recent years the choir has given concert versions of Gilbert & Sullivan's *Princess Ida* and *The Gondoliers*, as well as more serious cantatas and anthems. Times have changed and not so long ago the choir stalls were removed and the pulpit and altar significantly modified in order to provide a more open 'front of church'. They say the congregation can still sing as

lustily as ever but at the present time there is no choir, which is sad, because choral singing can make a worthy contribution to the life of the church and community both on special occasions and in weekly worship. It would seem that church music, like drama, has become an endangered species.

The Drama Society started in 1951 and aimed at producing two plays a year. The task was heavy but for a while the aim was achieved. Brenda Gould (née Cooper) was the producer from the start and she struggled with too few members. But she succeeded in putting on before crowded halls two or three nights of good and wholesome entertainment, with good actors and actresses like Bernard and Edith Scrivener, Olive Smallwood, Shirley Speck, Judith Crowson and many others. Ruth Brown and Stephen Walker also produced a number of plays, as well as taking on acting roles. One well-received play, 'The Younger End', was even taken on tour as far as Upperthorpe. Sadly this once vibrant church activity had to close because of falling numbers, as younger members went away to study at university or to take up work elsewhere in the country. This haemorrhaging of the traditional life-blood of any organisation, especially of the younger members, may even jeopardise the future well-being of the Society.

At one time the church felt it needed a parent–teacher association like those current in day schools. It was intended to act as a link between the teachers of the Sunday School and the pupils' parents. The association used to meet monthly and although numbers were never very strong, the contacts made were considered to be very worthwhile. Mr Derek Furniss was the Secretary and Mrs Buxton was a particularly active member while the association lasted.

The last half-century has seen many changes. The Youth Council which used to meet at the Firth Park Church was a representative council under the leadership of Mr Frank Crowson, but nowadays the Minister, the Revd Carol Parker, has the role of youth coordinator for the circuit. The group meets regularly on Sunday evenings and organises an annual youth weekend. Another lively group which is flourishing is the Wesley Guild, which meets weekly with a different emphasis each week according to the programme under the headings: Cultural, Devotional, Social and Christian Service. There was a group of Good Samaritans who met regularly and gave practical help to anyone in need. Twice a year it hosted a Tea with Entertainment for people living alone. A small group still leads a short service each month at the local care home. The 'H' Club is a group which organises an annual day out for anyone interested. It encourages people in the community to join in with the members for the day.

At a ceremony in July 1969 two stained-glass windows were placed at either side of the main entrance into the church. They were unveiled by Miss Doris Maycock, a deputy head teacher, and by Mr G.K. Sugden, the President of the UK Cutlery and Silverware Manufacturers' Association. The artist, Bryan Woodriff, selected for his designs the principal local occupations at the turn of the twentieth century: fork-making and farming. The completed windows were made and installed by Finch's Ltd of Sheffield at a cost of £210.

Later in the day a plaque commemorating the role Miss Hemmingfield's father had played in the church was unveiled by Mr Cyril Brown. It reads:

In May 1988 the church safe was stolen, with the consequent loss of many valuable documents including the Minute Books of the Trustees and others referred to in this

> Re-making of the chapel garden 1968
> Presented by Mildred Hemmingfield in loving memory of her father, Edmund
> Hemmingfield
> Life member 1873–1920
> Society Steward 1905–1920
> Sunday School teacher
> Band of Hope worker
> Violinist – member of choir and choral
> Christian Endeavour and cricketer.
> Favourite hymn: 'Master speak, Thy servant heareth'

book. Including the six people still remaining from the 1954 list of Trustees (W.R. Brookes, who has been Secretary since 1964; C. Brown; E. Cooper; G.S. Smith; C. Wragg and Miss M. Hemmingfield), the following have been Trustees at some time up to and since the loss of the documents: W. Claxton; P. Lockwood; D. Newbould; C. Sumner; D. Cadman; F. Crowson; P. Rowland; A. Austin; B. Norris; C. Dalton; M. Thoday; R. Mountain; Ms James; Mrs E. Brookes; Ms P. Smith; Ms S. Pratt; Mrs P. Thoday and Mrs J.A. Mountain.

A plaque on the clock states:

The buildings are always kept up to date and so in April–June 1990 the church

> This clock is in remembrance of Martha Elizabeth (Pattie) Rhodes
> June 14th 1889–January 7th 1969
> A loyal and devoted member of this church
> Sunday School secretary for 50 years
> President of the Sisterhood and Girls' Brigade
> Choir master and member
> Trustee for 33 years

vestibule was completely altered. The two central rear pews were removed and the existing wooden wall moved forward, thus creating a porch one-third bigger in area. Three coloured glass windows were inserted into the new wall. The central one was completed by Geoffrey Smith and the ones either side by Ron and Eva Brookes respectively. All the walls were lined with pine sheeting and new doors were fitted at the top of the aisles. The minister's vestry and office was removed from the ground floor of the Sunday School where it had been since 1938 and put back in its original place in the old vestry on the right-hand side of the porch, which in the past had served as both a library and a cloakroom. All this work was done in-house at a cost of £1,471. In January–February 1992 further alterations were made to the interior of the church. The choir pews at the front were dismantled, along with the flooring under them. The old pulpit was reduced in length and fitted with castors underneath to

make it more easily manoeuvrable. False window arches were fitted on the walls, each side of the organ, the ceiling was repapered, the church redecorated and a new carpet fitted around the organ and along the aisles, all at a cost of £5,035. Elsewhere in the church are several commemorative plaques to former members of the Society.

In 2004 it was realised that the 1928 organ was in desperate need of expensive repairs. Sadly the Church Council decided to vote for the sale of the old organ and the removal of the 100-year-old casing. This was effected in April 2005, leaving a huge gap at the front of the church. An electric console had already been installed as a replacement at the front of the church in 2003. The next move focused on the installation of a new central heating system and the debate about whether to remove all the remaining wooden pews, replacing them with chairs and levelling the floor in time for the sesquicentenary. The work was completed at the beginning of 2006. Will we come to regret these changes in the next half century?

Thus ends our brief outline of the past and present work of the Shire Green Church in the service of the community. It has had its ups and downs and attendances have been seriously affected by the counter-attraction of television and the general secularisation of society. The departure of the younger generation to attend college or to work elsewhere has also had an adverse effect on membership and the church's activities. The real worth of the church's contribution to community life cannot be measured; it can, however, be shared. Sunday worship is the focal point of all other work, and in the services we find the true spirit of the family together. It is there that people learn the will of God and then have the opportunity to go out into everyday life to practise it.

And the face of Shire Green itself, of Wincobank and beyond, is being radically altered with the loss of many well-known and much-loved landmarks and facilities. Almost all the vestiges of farming and fork-making have disappeared, while the variety of small shops that once sustained the community have been lost in favour of larger superstores and hypermarkets. The old Co-op facilities of grocery, greengrocery, meat, shoe-repairs, dairy produce, laundry and even home decorating have all been withdrawn and the buildings reused or demolished; Davy's, Meadow Dairy, Maypole, Shentall's, Priestley & Styan, Friedrich's, Wild's and many more have disappeared. Shire Green's cinemas – the Paragon, the Capitol, the Forum, the Sunbeam and the Roxy – have gone, like those at Wincobank and Ecclesfield. The picturesque lake in Firth Park was turned into a concreted paddling and boating pool, then into a hard surface basketball area which is rarely used; the bandstand in the park is long gone, while the open-air swimming pool in Longley has been closed and not replaced. Many other sporting facilities in the parks for individuals or local organisations have disappeared because the council has been too hard-pressed financially to maintain them. Buildings, parks and open spaces deteriorate, the odd public house closes its doors and even the few remaining historic buildings have been allowed to fall into a poor state of repair. Many have already been pulled down. Old stone walls are removed and even many council houses on the estates have had to be demolished and replaced by more modern housing in keeping with the latest regulations. Even though much has been done lately to enhance the general environment, there is still an overall impression that all vestiges of the past must be removed as they are no longer relevant to the new generations. There has been a gradual cultural change in the nature of the local population which seems to have no knowledge of or connection with the area's

past.

The end of the twentieth century saw the gradual erosion of attendance at many churches, several having closed over the last thirty years with the consequent loss of dedicated facilities and the resulting impoverishment of local community traditions. When the church in Barrow Road, Wincobank, closed its doors, its congregation largely transferred to Hatfield House Lane in Shire Green, as did the members of the Beck Road Church in Nether Shiregreen when, despite protests, it was closed down. A few went instead to the church of St James and St Christopher. Ebenezer in Ecclesfield, the last but one to join the north east circuit, also closed because internal repairs were too costly. It became a nursery. The Blackburn Church suffered the indignity of demolition when its neighbourhood of close-terraced housing was knocked down in the 1970s.

In 1938 the Revd W.E. Sangster wrote a vibrant book called *Methodism can be born again* in which he wrote that 'in the 18th and early 19th centuries it was generally understood in England that a Methodist chapel was a place where one went to get one's soul saved. Even those who spoke derisively of the "ugly Bethels" were in no doubt of the clear purposiveness of the people who worshipped there. If only that reputation could be won again!' he wistfully concluded.

John Wesley described the true Methodist as 'one who has the love of God shed abroad in his heart. One who loves the Lord with all his heart and soul and mind and strength . . . His heart is full of love of all mankind, purified from wrath, envy, malice and every unkind affection . . . He does good unto all men, neighbours, strangers, friends and enemies.'

Certainly Wesley's firm precepts have been the mainstay of the lives of the dedicated congregation of Methodists at Shire Green for over 150 years. This book has described some of their history and the traditions behind those odd bits of the jigsaw puzzle that may help one day to fill in some more of the picture of everyday life experienced by past generations in this small part of old Hallamshire.

Woolley Woods, lying south of the Ecclesfield Road alongside the railway line between Meadow Hall and Chapeltown, is an old wood stretching between Low Wincobank and Low Shire Green. Famous for its bluebells in late spring, it is also home to wood anemones, pink and white campions, wild strawberries and wild garlic, as well as fungi and a good variety of wild birds. Even tiny fresh-water shrimps have been seen in its brooks. It is a real nature reserve and a pleasure to walk through.

The rear of Maycock's farm and the allotments along Jedburgh Street, photographed from Standon Road looking towards Fife Street.

The Maycock family photographed in 1916 or 1917 on the eve of their two sons being called up for army service in the First World War. Left to right: Emily Maycock (née Ellis); Muriel Edith; Charles Gilbert; Gwendoline Louise; Thomas Edwin; Emily Dorothea and William C. Maycock. William was a good local preacher for the Primitive Methodists and often travelled on horseback or walked long distances to preach his sermons.

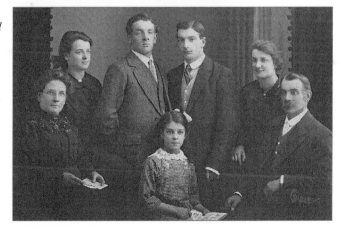

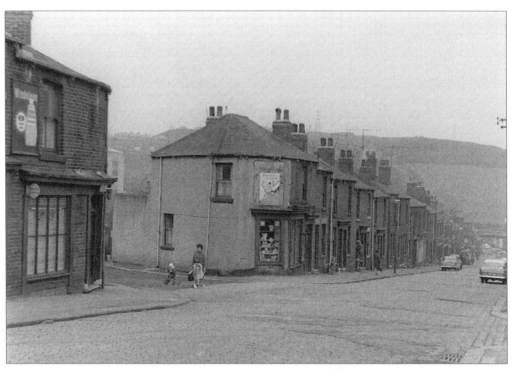

The west side of Fife Street looking from Ward's sweet shop down towards the Barrow Road railway bridge and Kimberworth Hill.

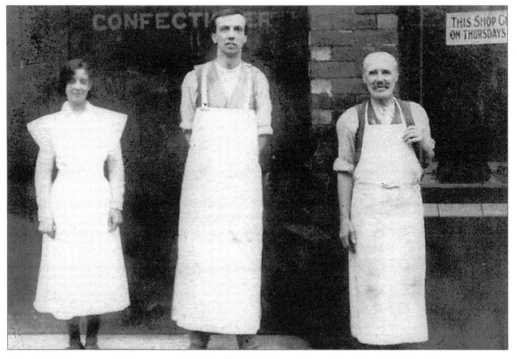

Kemble's bakery was at the corner of Merton Road (Picture House Lane) and Merton Lane. Mr Kemble is standing to the right of his two employees.

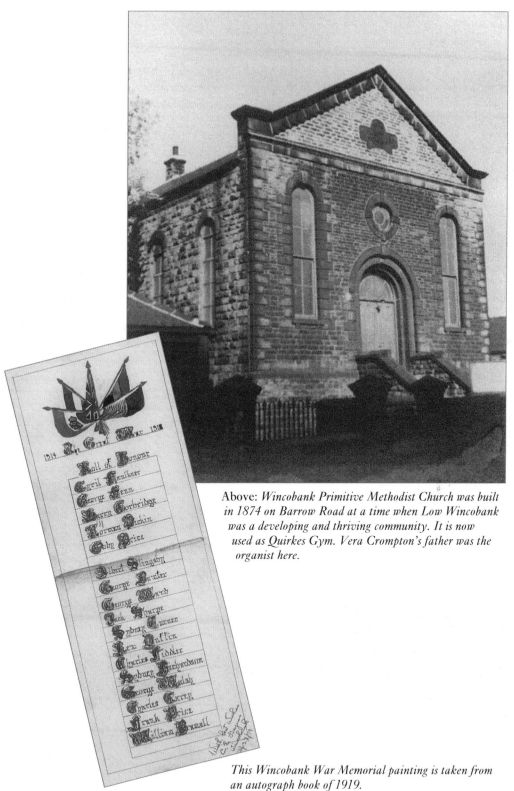

Above: *Wincobank Primitive Methodist Church was built in 1874 on Barrow Road at a time when Low Wincobank was a developing and thriving community. It is now used as Quirkes Gym. Vera Crompton's father was the organist here.*

This Wincobank War Memorial painting is taken from an autograph book of 1919.

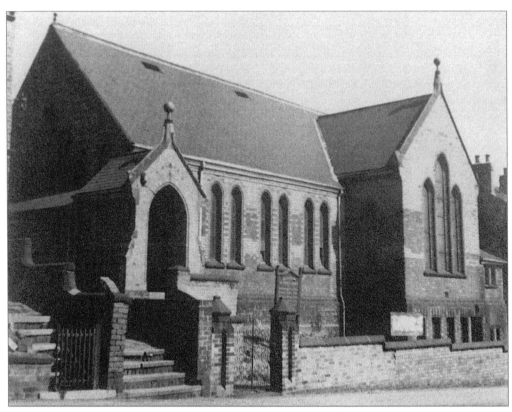

Pictured here in 1956 is the Blackburn Methodist Chapel, sandwiched between rows of terraced housing. It was established in 1845 and built on the Blackburn Road in 1894. Vera Crompton's father was the organist here, too. The chapel stood almost opposite the old Meadowhall station where now there are new houses. The church was demolished in the 1970s at the same time as the neighbouring houses.

The Roman Riggs – an ancient British earthwork that stretched from Kimberworth across the Blackburn valley to Wincobank Hill – seen in the distance with its 'castle' at the summit.

Blackburn's May Queen Dorothy Burgin and Sunday School Captain Gordon Stone in procession before entering the chapel, 1955. The attendant at the rear with the hoop of flowers is Jean Jenkinson. The annual ceremony took place against the unmistakable backdrop of two massive gas holders and the Yorkshire Engine Company.

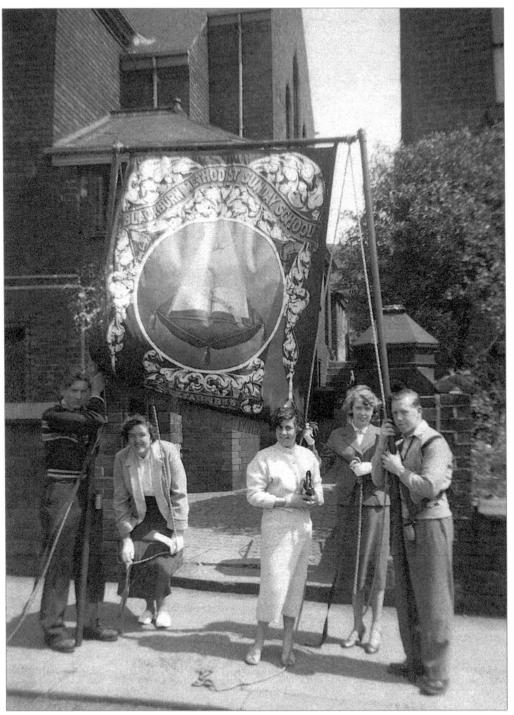

Standing with the Blackburn Sunday School banner just before the start of the Whitsuntide walk in 1956 are: (left to right) Gordon Hollis; Mavis Swift; Betty Bullock; Dorothy Burgin and Geoff Pearce. The walk was a significant local event, which involved the chapels and church of Wincobank and Blackburn, processing through the entire area and stopping frequently to sing hymns. It used to be well supported but times have changed.

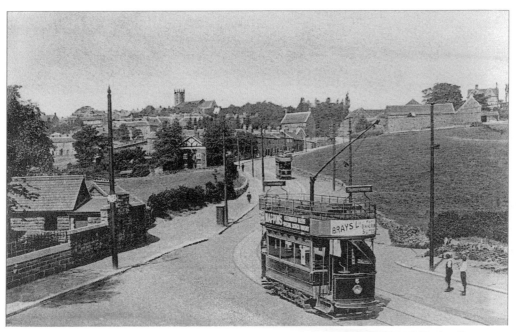

Rotherham Corporation trams on the Kimberworth Road ran past Psalters Lane and Masbro Cemetery on the left, past Lockwood Row cottages and Kimberworth House, towards St Thomas's Church. The Barns and Kimberworth Manor House are on the right.

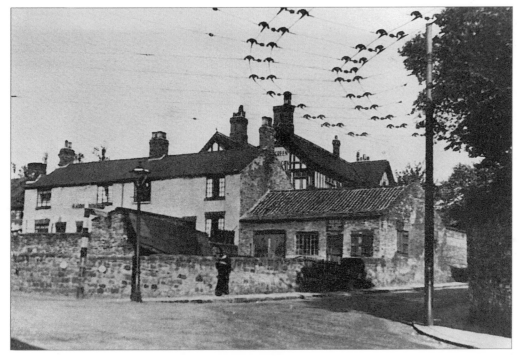

The trams were replaced by trolleybuses in 1929–31. Here one can see the corner junction of Meadowhall Road, High Street and Kimberworth Road showing the overhead wires. The old blacksmith's is in front of the Green Dragon public house.

Daphne Marshall of Jenkin Road, intrigued by the photograph of the lace-maker in a previous book, delved into the archives and discovered that the lady was indeed a relative of the Maycock family but was not Sarah Jowett, the one mentioned. In fact, she was Fanny Sanders née Alderman from Titchmarsh, Northants. She was the older sister of Millicent who married Thomas Clark Maycock and moved to Kimberworth and then Low Wincobank. Fanny's great-granddaughter, Mary Merchant, whom Daphne found and spoke to, is a friend as well as a relative of Joyce Brown née Manifold – herself distantly but directly related to the Maycocks. Mary still has examples of the lace which her great-grandmother made.

Thomas Clark Maycock, coal merchant and then butcher, with his wife Millicent, née Alderman, photographed in about 1880. They had both moved from Northamptonshire to Yorkshire – and Thomas brought his brother, too.

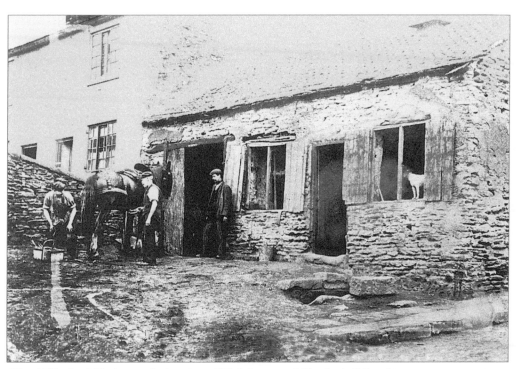

The old blacksmith's shop at the junction of High Street and Meadowhall Road.

A meeting of the Sheffield District Synod of the Primitive Methodist Connexion in Mexboro in May 1908. W.C. Maycock was among the delegates.

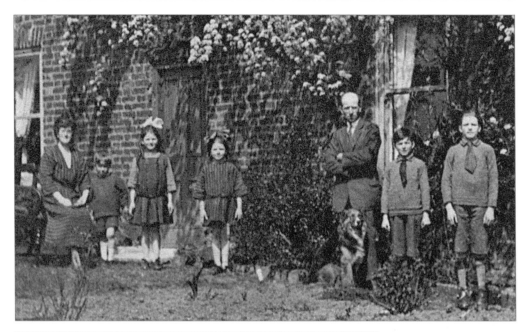

Above: *Red House Farm, Scholes, with another branch of the Ellis family. Minnie Ellis is seen here with her children Eric, Barbara and Emmie. Her husband George, brother of William at Hatfield House and Nether Shire Lane farms, stands with their dog and their two other sons Reg and Bob, who is wearing callipers.*

The Station Road Methodist Church in Chapeltown was built in 1907 and is now the gateway for the aptly named Chapel Lodge Nursing Home, which is a very impressive building. The church members moved to a new building.

Warren Methodist Church in Warren Lane was built in 1876. It has recently been refurbished for ongoing activities and worship.

Potter Hill Church at High Green, built in 1839, has been demolished.

Wortley Road Methodist Church in High Green was built in 1864 but heavy subsidence has forced the building to close. Its members have relocated to a new modern-style building.

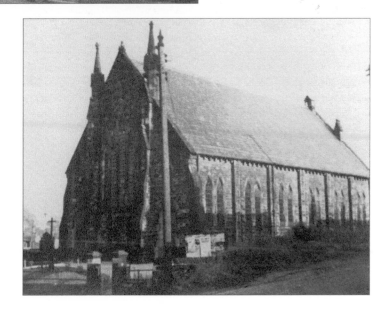

The 1970 six-man inspection team, consisting of Mr E Cooper, -?-, Mr Pye, Mr Oliver, Mr G. Kelk and Mr C. Brown, pictured in front of the Burncross Church, which was built in 1865 and closed about 1990. Its members joined the new Chapeltown Methodist Church.

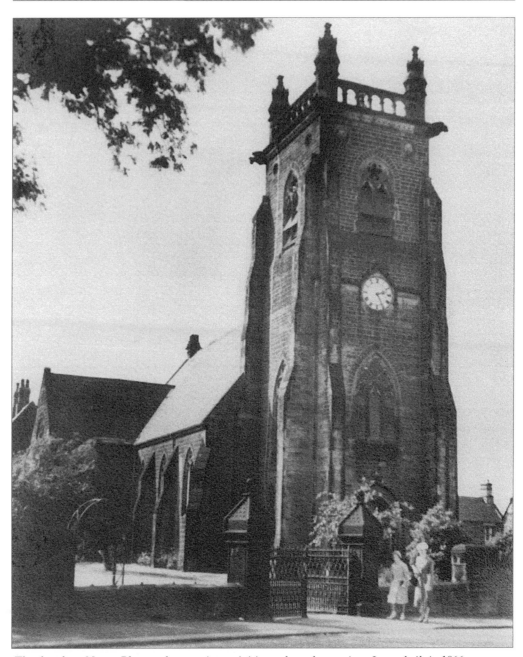

The church at Mount Pleasant has ongoing activities and regular services. It was built in 1866 on Station Road.

The little Methodist Chapel at Stoneygate, founded in 1877, has been demolished but a foundation stone of 1892 has been incorporated into the stone wall of a new bungalow on the site.

Below: *Newton Chambers' new coal by-product plant at Smithy Wood, as seen in 1960.*

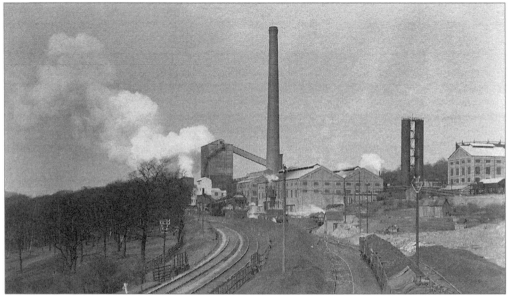

EPILOGUE

YESTERDAY, TODAY & FOREVER

BY THE REVD CAROL PARKER,
MINISTER AT HATFIELD HOUSE LANE METHODIST CHURCH

I am a newcomer to Sheffield and to Shire Green. I have lived here for only a few years, but I find it fascinating to look at the old pictures and to see what has changed – and what still remains. Sometimes I even manage to spot familiar faces in the photographs, albeit with much younger features! All of this points to the continuity between the past and the present. Yes, things do change but the past continues to shape and influence the present and the future, too. The actions and decisions of past generations still have their effect on us today.

At Hatfield House Lane Methodist Church we are thankful for the witness and service of those who went before us. They left to us a beautiful building, and more importantly a work of care and service in the community. We now try to continue and develop that work. It is with these aims in mind that the Church Council has recently agreed an exciting new building scheme.

The old organ that did such good service for many years has sadly given up the ghost and has now been removed and replaced with a new digital instrument which our organist is delighted with! The building scheme involves making good the back wall against which the organ stood, and putting in a new focal point. We will replace the old unreliable heating system with two new heating systems, one for the church and one for the rest of the premises, and we'll put in a new PA system too. The church pews will be removed and replaced by chairs on a new level floor to make the church multi-functional.

The church members trust that this new building scheme will maintain the beauty of the church, while equipping it for a new century and making it accessible to all. We believe that this is in the same tradition of faith and service that others followed before us and that we, like them, are enabled by Jesus Christ, who is the same yesterday, today and forever. At the beginning of January 2006 an amalgamation of the old Sheffield North East Circuit took place with the Methodist component of what used to be SICEM (Sheffield Inner City Ecumenical Mission). The new circuit comprises all the churches which used to be in the Sheffield NE, plus Pitsmoor, Grimesthorpe and the Furnival Methodist Churches. The new circuit has been named 'Sheffield Pilgrim Circuit' to recognise the journey of faith which we all travel and which brings changes, challenges and growth along the way.

Revd Tom Stukey, President of the Methodist Conference, outlining the theme 'passion, mission, motivation' in front of a well-attended 150th anniversary and rededication service, 2 April 2006.

There are always changes; the village has gone but the past lives on in the lives of a new generation. And the values that many held in the past, values of kindness, justice, forgiveness and respect, are things that are eternal. It is up to us to make them real in our own age and time.

The limited edition of the sesquicentenary commemorative mug.

APPENDIX I
MINISTERS, QUEENS & CAPTAINS AT SHIRE GREEN

MINISTERS

1836–18?? Revd George Marsden ('Wesleyan')

1856–185? Revd John Brownson ('Primitive Methodist' Superintendent Minister)

185?–1886 Not known

1886–188? Revd G. Lee

189?–1897 Revd W.S. Barrett

1897–1900 Revd M. Browne Stamp

1900–1902 Revd Ralph Laidler

1902–1905 Revd Daniel C. Cooper

1905–1907 Revd Ernest Lacey

1907–1908 Revd Francis Laidley

1908–1911 Revd Thomas Bonney

1911–1914 Revd A.E. Rose

1914–1917 Revd H.J. Marsh

1917–1922 Revd J. Herbert Barker

1922–1927 Revd H. Fox

1927–1930 Revd A. McGain

1930–1934 Revd J.R. Whitty

1934–1937 Revd J. Moorhouse

1937–1938 Pastor D.E. Parsley

1938–1939 Pastor H. Bentley

1939–1940 Pastor J.W. Hutchinson

1940–1943 Revd Leonard Brown MA

1943–1946 Revd Frank Masters

1946–1948 Revd Walter C.H. Fell

1948–1952 Revd John A. Clayton

1952–1958 Revd William Leary

1958–1963 Revd Derek H. Jefferson

1963–1965 Revd K. Waterhouse

1965–1971 Revd Albert W. Chant

1971–1975 Revd Gordon E. Webster

1975–1979 Revd John Lacey

1979–1982 Revd Peter Lancaster

1982–1987 Revd Roger M. Leslie

1987–1991 Revd Frank McBrien

1991–1998 Revd Bernice Ambrose

1998–2001 Revd Lawrence Wallace

2001– Revd Carol Parker (née Hill)

SUNDAY SCHOOL QUEENS & CAPTAINS

1932 Margaret Sandall and Kenneth Smith

1933 Mary Lee and Ronald Brookes

1934 Doreen Brookes and Horace Deakin

1935 Laureen Rhodes and Dennis Buckley

1936 Jessie Green and Bernard Scrivener

1937 Gwyn Brookes and Neville Smith

1938 Patricia Murphy and Horace Selman

1939 Kathleen Rhodes and Percy Roden

1940 Kathleen Hollingsworth and Roy Baldock

1941 Rita Wragg and Bernard Frith

1942 Eileen Rhodes and Owen Hanson

1943 Avis Hemmingfield and Michael Sinclair

1944 Kathleen Hird and Gordon Cooper

1945 Doreen Maw and Kenneth Roden

1946 Margaret Helliwell and Geoffrey Holder

1947 Velma Furniss and Bryan Woodriff

1948 Olive Gregory and Geoffrey Smith

1949 Margaret Brown and Peter Mitchell

1950 Janet Chaloner and Peter Locker

1951 Betty Sharpe and David Budd

1952 Patricia Smith and Peter Marriott

1953 Kathryn Wragg and Francis Brewster

1954 Pauline Rawson and Leonard Cox

1955 Christine Helliwell and Brian Bailey

1956 Maureen Purcell and Graham Townsley

1957 Margaret Slater and John Watson

1958 Marion Dewey and Ian Bilson

1959 Diana Dowker and Paul Smith

1960 Jean Townrow and Trevor Shaw

1961 Roma Cooper and David Johnson

1962 Judith Crowson and Stephen Walker

1963 Patricia Jackson and Roger Crowson

1964 Rita Flinders and Glynn Bilson

1965 Linda Cotterill and Robert Townrow

1966 Susan Adamson and David Keyes

1967 Susan Adamson and David Keyes

1968 Adele Walker and Peter Lockwood

1969 Pauline Woods and John Brookes

1970 Elizabeth Adamson and Richard Brown

1971 Ann Siddall and John Strutt

1972 Joan Milner and Richard Southern

1973 Sheila Sylvester and David Newbould

1974 Helen Nodder and Nigel Pratt

1975 Diane Sarjeant and Kevan Cadman

1976 Lynn Slater and Mark Sinclair

1977 Dawn Claxton and Andrew Sinclair

1978 Tracey Richardson and Robert Newbould

1979 Kathryn Nodder and Geoffrey Newbould

1980 Janet Claxton and Ian Blackett

1981 Judith Nodder and David Claxton

1982 Elizabeth Haresign and Richard Womersley

1983 Jayne Houseley and Philip Rowland

1984 Karen Seville and Stephen Nodder

1985 Ann Thoday and Christopher Mason

1986 Lesley Haresign and Richard Ulyatt

1987 Sharan Ulyatt and Peter Mason

1988 Helen Staniforth and Lee Thoday

1989 Laura Bedford and Andrew Tipple

1990 Sarah Shaw

1991 Katherine Scott

1992 Samantha Christer

1993 Michelle Christer

APPENDIX II
ROLL OF HONOUR, 1939–45

THOSE WHO DID SERVICE DURING THE SECOND WORLD WAR

Frank Allen

Ron Allen

Leonard Atkinson

Roy Baldock

John W. Barningham

Leslie Beaumont

Harold Bell

Clifford Bilson

Harold Booth

Cyril Brown (prisoner of war)

Alan Burgin

George Cheetham

Alan Coleman

Desmond Cooper

J. Coupe

Frank Crawford

E. Cross

Mary Cross

P.T. Cross

S. Davenport

H. Deakin

Horace Deakin

Sidney Deakin

Jimmy Fox

F. Gordon

F. Green

Edith Guest

C. Hague

Sidney Hall

Neville Ironside

S. Kellett

Gwenneth Knight

A. Lewis

D. Mann

Edwin Mitchell

Joyce Nelson

Douglas Newbould

F.A. Newhall

Ernest Orgill

Harold Roden

Percy Roden

Derrick Ross

Bernard Scrivener

Harold Selman

H.C. Smith

Jack Smith

Kenneth Smith

Neville Smith

Ron Smith

R.G. Smith

L. Staves

Ron Steggles

Leslie Sylvester

Harold Talbot

Kenneth Talbot

E. William Topham

Barry Trodd

Kenneth Walker

F.T. Wing

C. Woodhead

Joan Worrall

Lonely I wander down the ways of my childhood,
They bring back such memories of happy days of yore.
But gone are the old folk, and the house looks deserted,
No lights in the windows, no welcome at the door.
It is here where as children we played in the park,
It is here where we fished in the pond and the burn.
But where are they now, those friends of my youth?
Are they dead, are they gone, no more to return?
Empty my house stands down the lane of my memory
For the children have flown, the old folk have gone.
So why do I stand here like a ghost in the shadows?
It's time I was moving, it's time I passed on.